Painting Seascapes

IN OILS

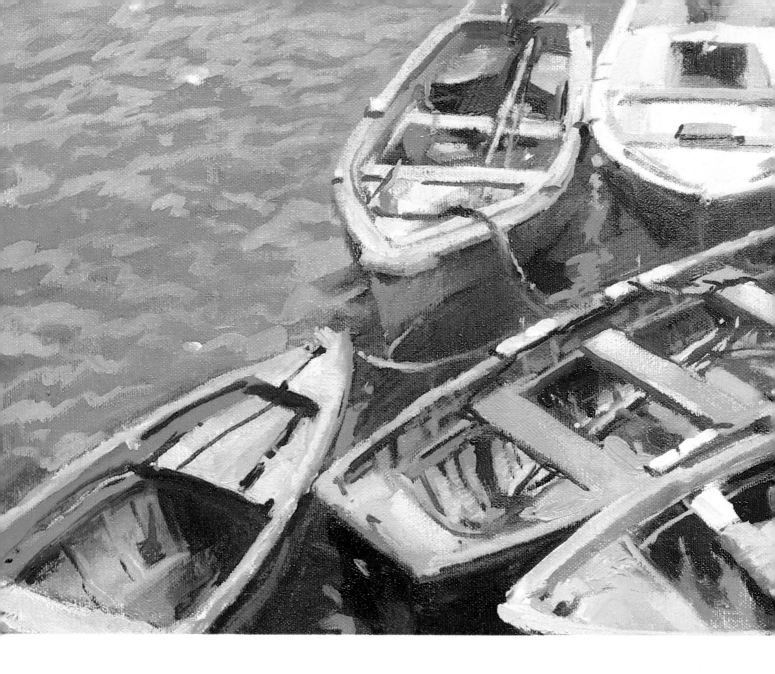

All inquiries should be addressed to:
Barron's Educational Series, Inc.
250 Wireless Boulevard
Hauppauge, New York 11788

Library of Congress Catalog Card No. 95-31108

International Standard Book No. 0-8120-9401-8

Library of Congress Cataloging-in-Publication Data
Marinas al óleo, English
 Painting seascapes in oils / [author, Parramón Ediciones
Editorial Team ; illustrator, Miquel Ferrón].
 p. cm. — (Easy painting and drawing)
 ISBN 0-8120-9401-8
 1. Marine painting—Technique. I. Ferrón, Miquel.
II. Parramón Ediciones Editorial Team. III. Title.
IV. Series: Easy painting and drawing.
ND1370.M36513 1996
751.45'437—dc20 95-31108
 CIP

Printed in Spain
6789 9960 987654321

E A S Y
Painting & Drawing

IN OILS

Painting
Seascapes

BARRON'S

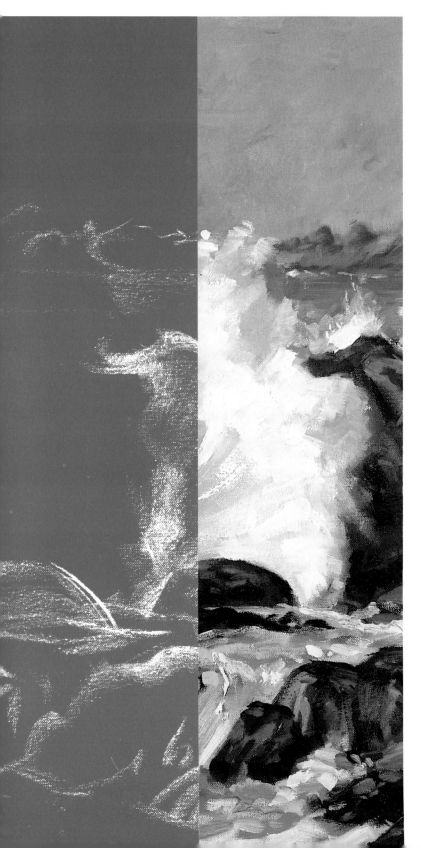

CONTENTS

*T*he sea arouses so many feelings that it's easy to understand why artists through the ages have painted it so often.

This book should capture something of the same passion. I am sure the fascination of the subject matter, combined with the way we explain the various techniques, will help you appreciate the reasons why seascapes are so fascinating.

Whatever subject you paint, no matter how inexperienced or expert you are, you should always make sure that the various parts of your work proceed in harmony with each other. The canvas must be painted as a whole. This means you must resist the temptation to finish each fragment or detail of the picture before moving on to the next one. A fragmentary technique will leave your painting looking like a mosaic. The individual parts may be very good, but they won't hold together. They won't belong. The result will probably be chaotic, lacking in unity and personality.

When you paint, make sure that the whole work is taking shape, with all the parts developing in relation to one another until the entire work is completed. Begin by painting general areas of color, marking out large patterns of light and shade, placing objects, and indicating the various tonalities. This means working from the general to the particular, constantly bearing in mind that the final result must be a unified whole. From time to time you should lay down your brush, stand back, and take a good look at the work done so far. This enables you to see mistakes. You find things that have to be adjusted or modified, and details that you have overlooked. A good painter must be a good

observer, and this applies to both the subject depicted and the painting itself.

At the end of the more general painting, and only then, you should begin with the details or secondary elements, putting in finishing touches wherever necessary. If this is not the way you usually paint, please give it a try. I'm sure you'll appreciate the difference.

I hope you will enjoy reading this book—and doing the exercises—as much as I have enjoyed preparing it for you.

Jordi Vigué

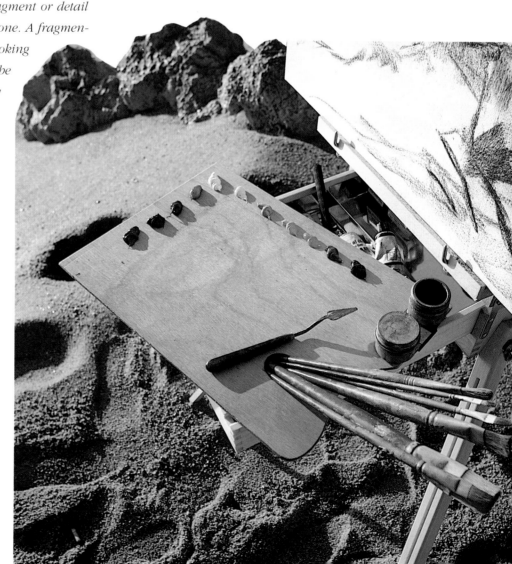

MATERIALS FOR OIL PAINTING

T he following pages present the more important materials that you need for oil painting. The actual paints come in various sizes, which should be selected according to your needs. Sizes are indicated on paint tubes in both fluid ounces (fl. oz.), and either cubic centimeters (cc) or milliliters (ml). The most common sizes are 20 to 25 cc, 35 to 40 cc, and 60 cc, although the sizes for white, which is the color most used, go up to 115, 120, 150, and 250 cc. The bigger sizes are most often used only by professionals. Figure F shows the basic materials you need for oil painting. The box comes with a palette, three brushes of different sizes, a palette knife, a small bottle of turpentine, some sticks of charcoal, small containers for oil and turpentine, and a range of colors that should be selected in accordance with your taste and requirements.

BRUSHES

Figures D and G show a wide range of brushes. Each size has a number that indicates the width. The numbers usually go from 0 to 22 and increase by twos (0, 1, 2, 4, 6, 8, 10, and so on). The brushes shown in the illustration are made of bristle, the type most frequently used in oil painting. Those on this page are flat; those on the facing page, called filberts, have rounded tips. Of course, there are many other kinds of brushes that are suitable for oil painting. Some are made of synthetic fibers. The softer ones are made of ox, sable, or mongoose hair. All these brushes can be used along with others, depending on the subject you're painting or the effect you want to achieve.

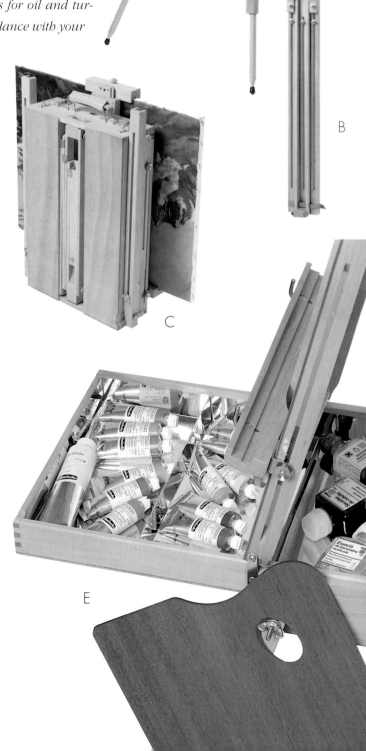

A

B

C

D

E

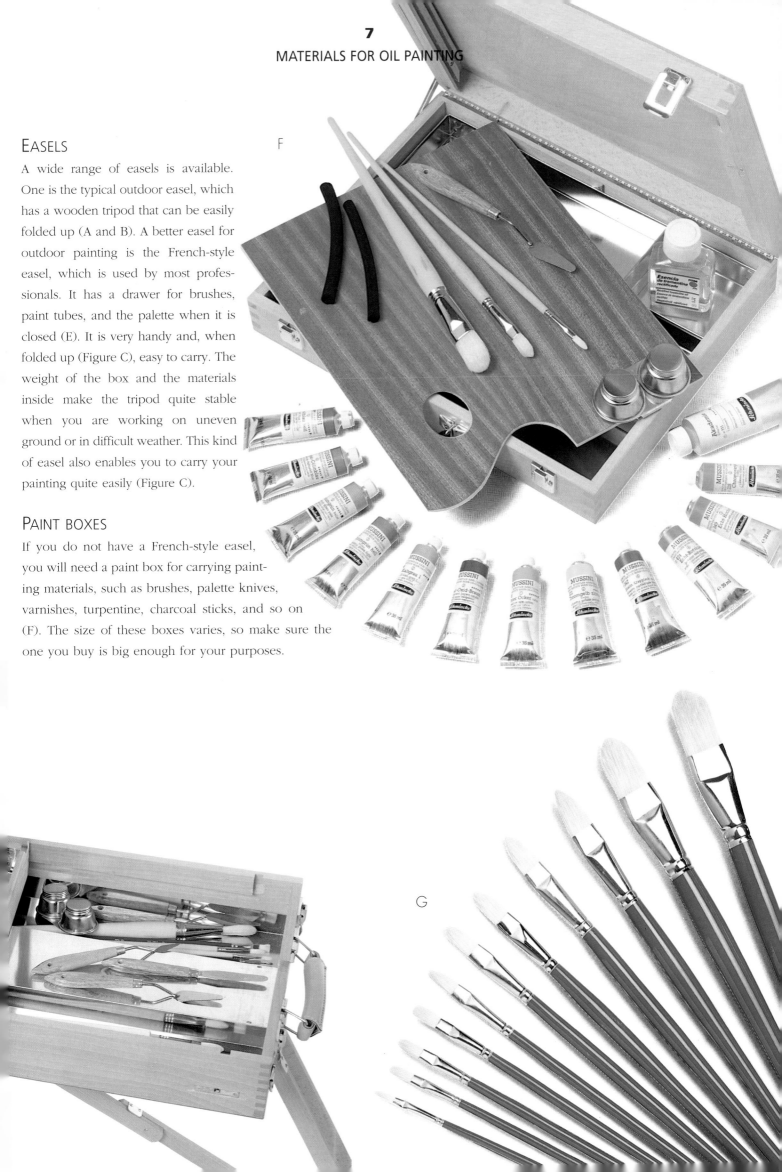

EASELS

A wide range of easels is available. One is the typical outdoor easel, which has a wooden tripod that can be easily folded up (A and B). A better easel for outdoor painting is the French-style easel, which is used by most professionals. It has a drawer for brushes, paint tubes, and the palette when it is closed (E). It is very handy and, when folded up (Figure C), easy to carry. The weight of the box and the materials inside make the tripod quite stable when you are working on uneven ground or in difficult weather. This kind of easel also enables you to carry your painting quite easily (Figure C).

PAINT BOXES

If you do not have a French-style easel, you will need a paint box for carrying painting materials, such as brushes, palette knives, varnishes, turpentine, charcoal sticks, and so on (F). The size of these boxes varies, so make sure the one you buy is big enough for your purposes.

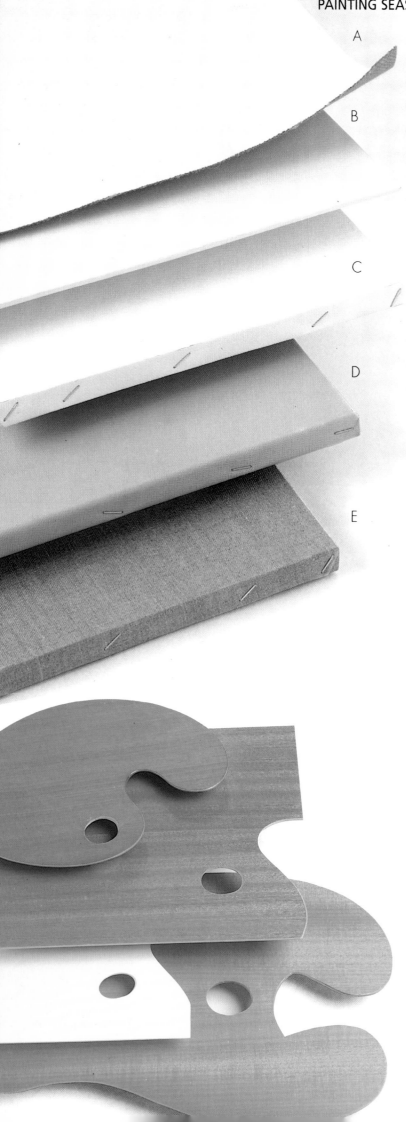

STRETCHER SIZES
(in inches)

STANDARD		MEDIUM DUTY		HEAVY DUTY	
8	26	8	28	18	62
9	27	9	30	20	64
10	28	10	32	24	66
11	29	11	34	30	68
12	30	12	36	32	70
13	31	14	38	36	72
14	32	16	40	40	74
15	33	18	42	42	76
16	34	20	44	48	78
17	35	22	46	50	80
18	36	24	48	52	82
19	38	26		54	84
20	40			56	86
21	42			58	88
22	44			60	90
23	46				
24	48				
25					

CANVAS

Canvas for oil painting is usually stretched across wooden stretchers. Numerous sizes of stretchers are available, varying in both height and width. Canvas can be bought in several forms. It may be unstretched (A), fixed to a cardboard base (B), or prestretched on a wooden stretcher (C, D, E).

PALETTES

Palettes come in many shapes and sizes. The most common ones are rectangular and are usually included in paint boxes. Round ones are sometimes called studio palettes, since they often don't fit into the boxes used for outdoor work. Very large palettes are used only for indoor painting. The white palette shown in our illustration is made of plastic, making it easy to clean.

TITANIUM WHITE	LEMON YELLOW	CADMIUM YELLOW	OCHRE

COLOR CHARTS

Most of the major manufacturers print charts showing the range of colors they offer. These charts indicate the exact tone and intensity of each color. Note, for example, the subtle variations in the yellows, greens, reds, and blues. The relative transparency and purity of the colors depend on their quality.

RECOMMENDED COLORS

At the bottom of the page you can see the colors that have been used to complete the exercises in this book. Of course, different painters have different preferences, and there could be variations in a few of these colors. But the selection shown here is a good basic range that should enable you to mix colors to obtain the exact tone you want.

THE MANUFACTURE OF OIL PAINTS

Oil paints are basically made by mixing pure high-quality pigment with a small quantity of linseed oil and a few minor additives like wax. This should give a completely uniform consistency. The paints are sold in aluminum tubes.

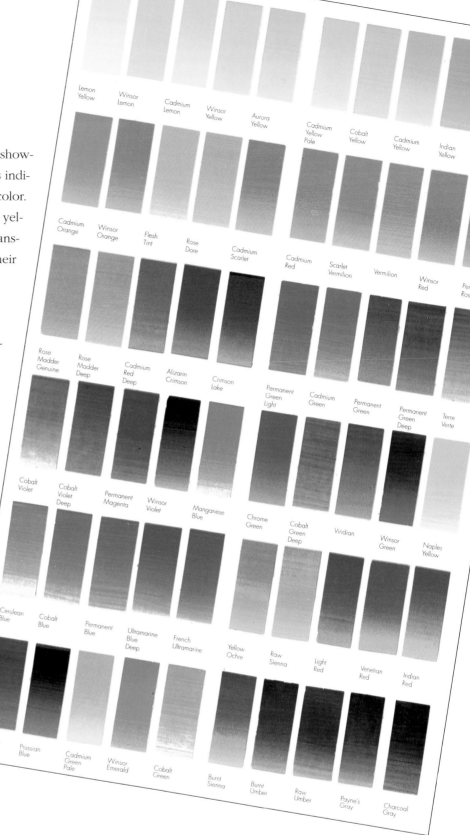

Lemon Yellow · Winsor Lemon · Cadmium Lemon · Winsor Yellow · Aurora Yellow · Cadmium Yellow Pale · Cobalt Yellow · Cadmium Yellow · Indian Yellow · Cadmium Yellow Deep

Cadmium Orange · Winsor Orange · Flesh Tint · Rose Dore · Cadmium Scarlet · Cadmium Red · Scarlet Vermilion · Vermilion · Winsor Red · Permanent Rose

Rose Madder Genuine · Rose Madder Deep · Cadmium Red Deep · Alizarin Crimson · Crimson Lake · Permanent Green Light · Cadmium Green · Permanent Green · Permanent Green Deep · Terre Verte

Cobalt Violet · Cobalt Violet Deep · Permanent Magenta · Winsor Violet · Manganese Blue · Chrome Green · Cobalt Green Deep · Viridian · Winsor Green · Naples Yellow

Cerulean Blue · Cobalt Blue · Permanent Blue · Ultramarine Blue Deep · French Ultramarine · Yellow Ochre · Raw Sienna · Light Red · Venetian Red · Indian Red

Winsor Blue · Prussian Blue · Cadmium Green Pale · Winsor Emerald · Cobalt Green · Burnt Sienna · Burnt Umber · Raw Umber · Payne's Gray · Charcoal Gray

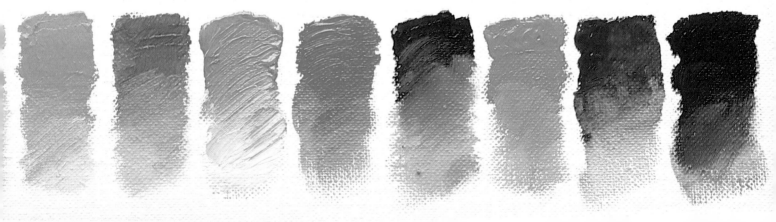

VERMILION · ALZARIN CRIMSON · TURQUOISE · ULTRAMARINE · VIOLET · CADMIUM GREEN · EMERALD GREEN · RAW UMBER

TECHNICAL ASPECTS OF OIL PAINTING

*W*hen painting in oils, as in any other medium, you must know how to use the basic techniques properly. You should be very aware of both the medium's possibilities and its limitations. The illustrations and advice given on the following pages should help you understand how to mix and use colors. Together with our notes to the exercises, these points should help you acquire the skills needed for the correct use of oils.

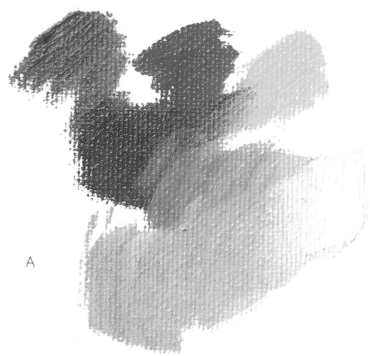

A

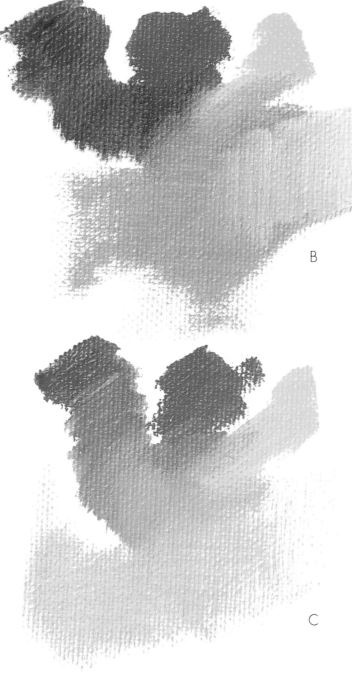

B

C

HOW TO OBTAIN DARK TONES

Figure A shows how a very dark color can be obtained by mixing the three primary colors: réd, blue, and yellow. This mixture gives a strong tone that is dark enough to replace black but that is still luminous.

MIXING THE PRIMARY COLORS

Figure D shows how a mixture of red and blue gives purple. The complement of this color is yellow, since it is the remaining primary. The complement of blue is a mixture of the two other primary colors, red and yellow, which make an orange tone when combined.

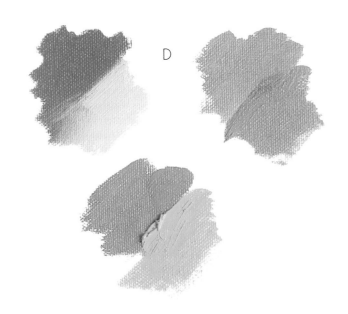

D

THE LUMINOSITY OF DARKER TONES

The left side of Figure E shows how a dark color can be obtained by mixing emerald green and alizarin crimson in equal parts. The right side starts with a pure black. When the colors on the right and left sides are mixed with increasing amounts of white, important differences appear. The mixture on the left, which is quite dark without the white, reveals color and light when the white is added. The straight black on the right produces no more than an amorphous tone that lacks luminosity.

E

F

G

THE USE AND ABUSE OF WHITE

In Figure F you can see what happens when a color is diluted with turpentine. Even though the red color is not very satisfactory, it becomes quite transparent and thus luminous. Much the same effect can be achieved by mixing a color with white, as we have done with the blue in Figure G. This also gives clarity and luminosity. But you should be careful not to use too much white, since this can make your colors chalky.

EASELS

We have already talked about an outdoor easel, which is the kind we used for the exercises in this book. But there are other kinds of easels designed especially for indoor work. If you prefer to work indoors, your dealer can show you models ideally suited for this purpose.

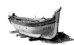

A FEW TECHNICAL POINTS

If you want to paint strokes of pure color on a dark background, you should use a brush with soft hair (synthetic or ox hair). To avoid picking up the background tone, apply the color gently, without pressing down. You can also use a palette knife to apply pure colors and to achieve certain three-dimensional effects.

SUBSTANCE AND TEXTURE

Oil paints can be mixed with other substances to make impasto or thick paint that adds texture. Below you can see how a palette knife is used to mix a color with marble dust to produce a very earthy texture. The use of such substances can help offset an excess of flat color. Oil paints can be mixed with sand, plaster, gypsum, or any other ground material. The resulting effects of substance and texture are used most often in highly subjective paintings.

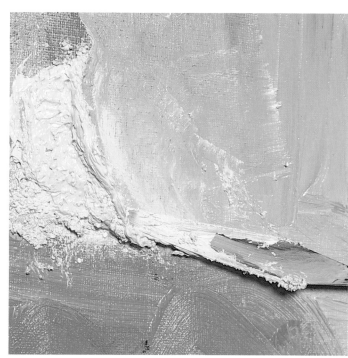

TYPES OF CANVAS

Canvas comes in different textures, from very smooth to very rough. The illustration at the right shows how different effects can be obtained with different textures. Figure A is the result of dry color on medium-texture canvas; B shows the same with a very rough texture. The quality and texture of your canvas should suit the subject you are going to paint, so you should bear this in mind whenever purchasing materials.

CLEANING BRUSHES

Cleaning brushes is very important and should be done with care. Once you have finished painting, put the brushes in turpentine to dissolve the paint left on them, then dry them with a clean rag. Although the brushes may look clean after this, they still have particles of color that can't be seen. Put the brushes under running water and wash them with soap, as shown in the photographs below. Once they have been dried, they will be perfectly clean and ready for further work. Brushes should be stored either flat or upright, with the bristle at the top.

TAKING CARE OF BRUSHES

If brushes aren't cleaned properly and go for more than a few days without being used, the paint on them will dry and they will become unusable. If you can't wash them as soon as you finish painting, take care that they are at least kept in turpentine until you can. But if you have to leave them for more than a few days, you must give them a full cleaning.

PAINTING A BEACH AT LOW TIDE

We begin our series of seascapes with a relatively simple scene that will help you grasp the basic techniques of seascape painting. You will be able to practice mixing colors without worrying about the forms and details that pose problems when painting more complex subjects. In fact, this book will go from exercises that are relatively simple to those that are more complicated. But all the exercises require the basic techniques of oil painting. If you follow our instructions and notes carefully, you should soon have a good command of these skills.

MATERIALS

- White canvas on 15" × 22" stretchers
- Charcoal stick for drawing
- Brushes: flat bristle number 14, flat synthetic number 12, and round bristle number 8
- Rectangular palette
- Colors: titanium white, medium yellow, ochre, vermilion, alizarin crimson, turquoise blue, ultramarine blue, cadmium green, emerald green, cobalt violet, and raw umber.

The color of the sky has been obtained by mixing white, turquoise, burnt umber, and raw umber.

This particular area brings together a wide range of cool and warm tones, creating a sense of translucence. The warm colors come from mixing white, orange, and raw umber. The touches of cool color are a mixture of white and ultramarine.

1 Our subject presents an attractive range of colors and has no really difficult forms. The beach at low tide creates a very special sensation due to the transparency of the water and the mixture of cool colors with the warmer colors of the rocks and the sand.

2 The initial charcoal drawing indicates the main areas to be colored. It's a good idea to take a few photos at this stage so you can refer back to the scene later.

The earth-colored strokes that underscore the shape of the waves were obtained by mixing emerald green and ochre. This area also has some strokes of pure emerald green.

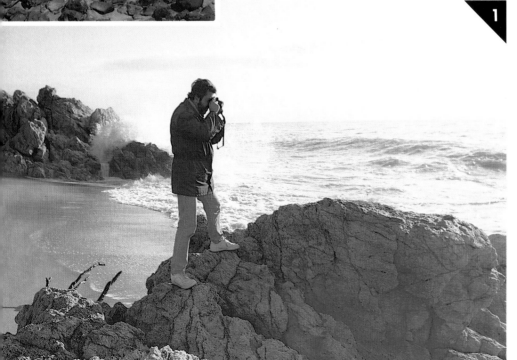

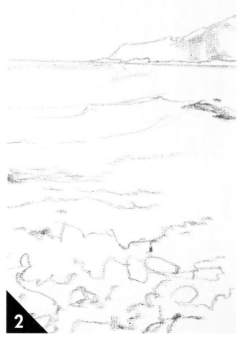

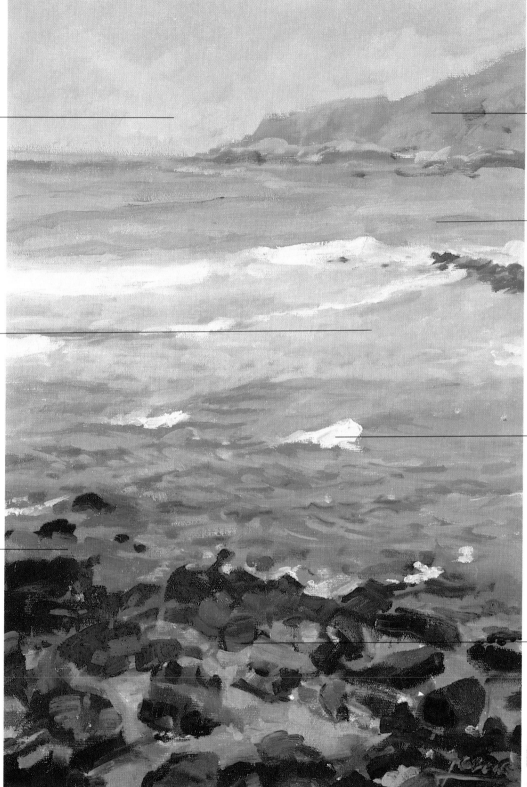

The hills in the background have been colored with white, cobalt blue, and raw umber, with nuances of emerald and ochre.

The part of the sea that is farthest away has the most pure and luminous colors, mostly turquoise toned with white. Strokes of emerald green suggest the movement of the waves.

Short strokes of pure white give the effect of the spray produced by the waves. The color is applied directly, and a few quick strokes then blend the edges with the underlying color.

The rocks and pebbles in the foreground have been painted with various dark tones obtained by mixing and alternating umber, alizarin crimson, and ultramarine.

3 Put in the general colors for the rocks in the foreground, since they are the painting's most concrete form. This can be done with a synthetic number 12 brush using raw umber slightly diluted with turpentine.

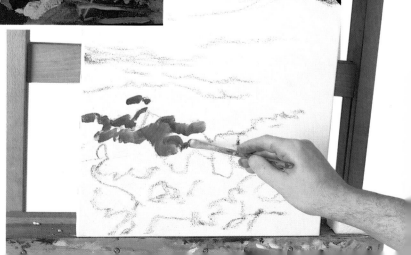

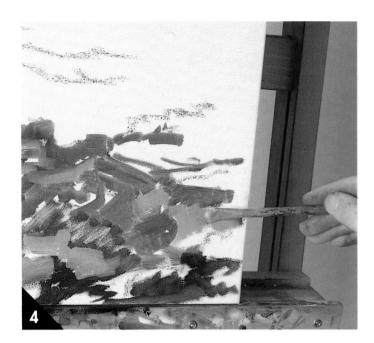

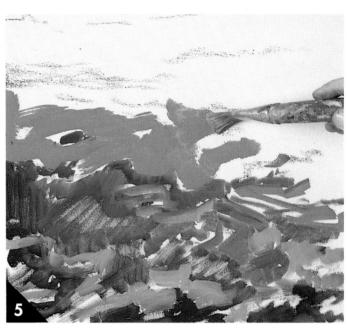

4 Continue with the foreground colors, painting the areas of clearer color with a combination of raw umber, white, and turquoise. At this stage all your colors should be kept separate on the canvas. They should be applied fairly quickly so you achieve a general coverage as soon as possible.

5 We now move toward the center, painting with emerald green, ochre, and a little white. This should give a general tone expressing the way the transparency of the water allows the color of the underlying sand to be seen. Use firm brushstrokes that follow the movements you can see in nature.

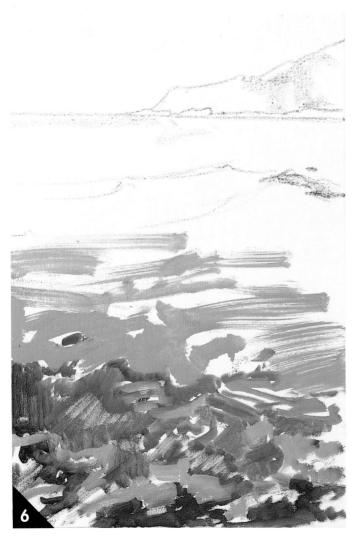

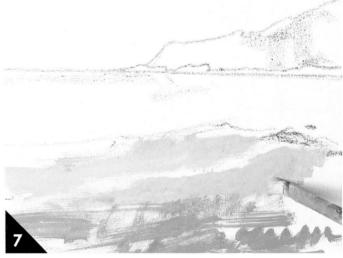

6 We pause at this stage for a general overview and to insist on the need to work quickly. These strokes should be done quite freely, without worrying about all the details that will be put in later.

7 Toward the background we have an area where the colors of the water are purer and bluer. The general tone here is a mixture of turquoise and white. As you can see, we are filling the canvas with the background colors that will be modified and corrected later.

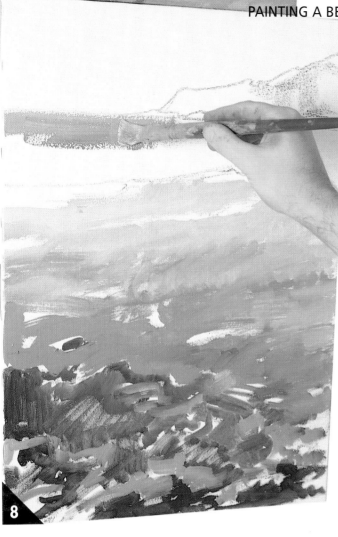

8 The sea along the horizon has the purest color in the scene. Here we have used turquoise blue for the entire area.

9 The background color for the hills is a soft tone obtained by mixing turquoise, white, and just a little raw umber to break the clarity.

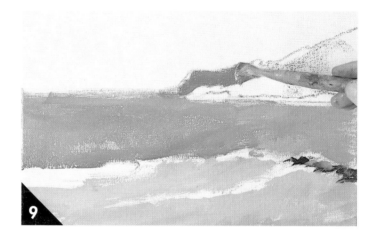

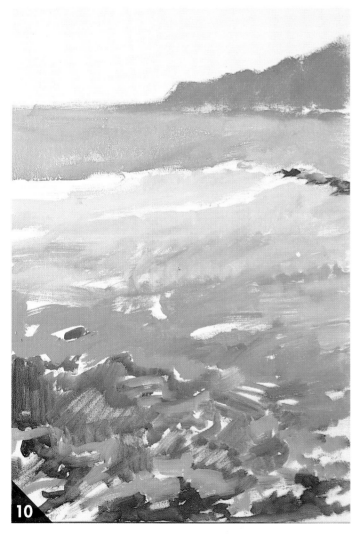

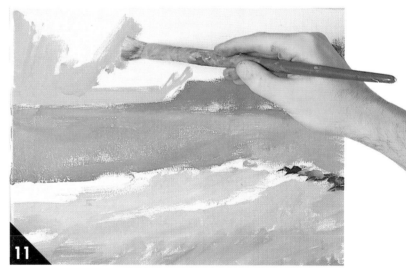

10 We pause once again to point out a further aspect of the work. As you can see, each section has to be painted as part of a whole. To achieve this, you should work as quickly as possible to fill the entire space.

11 In order to cover the remaining canvas, you should color the sky with a soft tone obtained by mixing turquoise and white with a little raw umber. Of course, these are not the final colors. They are no more than the general tones that we select on the basis of our initial observation.

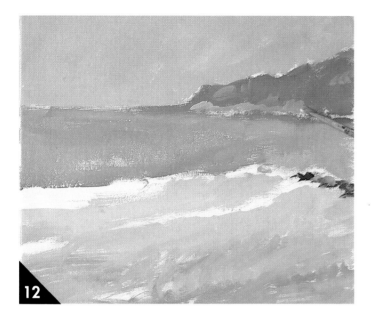

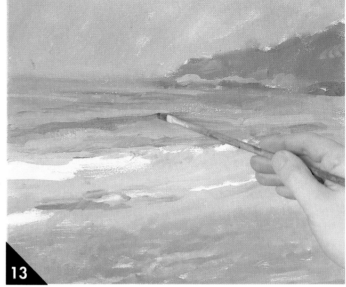

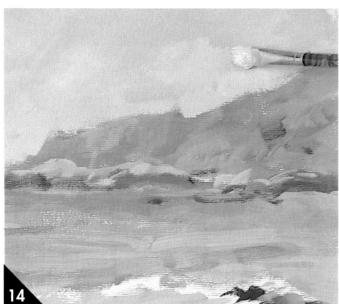

12 Now we start making our colors more definite and distinct. The shape of the rocks in the background is suggested by a few strokes using the base color of the mountains mixed with a little white.

13 Since the sea is constantly moving, you have to fix just one moment in your mind. The general movement of the waves should be suggested in accordance with this moment. Here we have used a mixture of turquoise and emerald green.

14 Never spend too long working on just one area to the detriment of the painting as a whole. For this reason we return to the sky and add a few lighter colors just above the hills. This is done with a mixture of turquoise and white, which is then blended with the base color.

HOW TO PROCEED

You must always see your painting as a whole, especially when working on an outdoor scene. Don't start with details and don't spend to much time on them. First paint the general areas of color. This should help you locate forms and configure the broad lines of the painting. Only after this is done should you turn your attention to the details.

15 Now we go back to the hills in the background to put in a few strokes of green plus some subtle golden tones to create a sense of depth and richness of color. Be careful not to pay too much attention to minor points. Paint firmly and confidently, since too many details in such a distant area would create little more than a distraction.

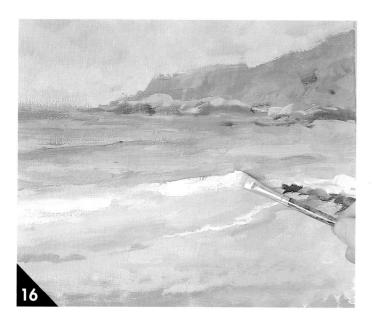

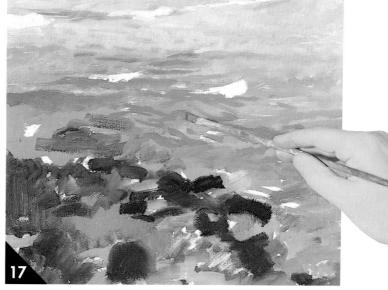

16 As you can see, we are slowly working our way toward the foreground, but without actually finishing any one section. The foam on the waves is painted with strokes of pure white, which should be applied as boldly as possible.

17 The light swell in the area lower down on the canvas is suggested by painting the shadows at the bottom of the waves. These shadows are a mixture of emerald green and ochre. To reproduce these colors, you first have to observe nature carefully.

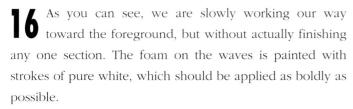

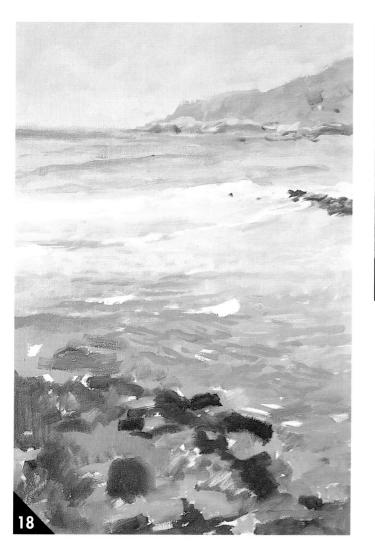

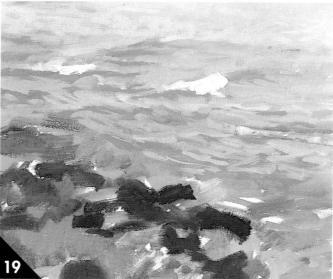

18 Now we have an overview of the entire canvas. Next come a series of adjustments and details in the foreground to give depth to the painting as a whole.

19 The lighter areas in the waves are defined with clear strokes of ultramarine mixed with turquoise and a little white. This enables us to suggest the size and shape of the waves.

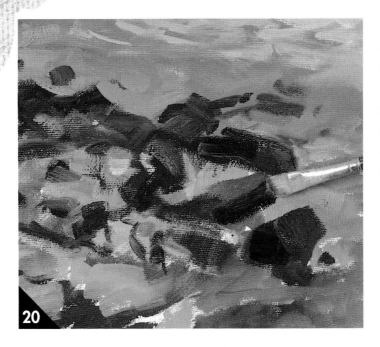

20 The rocks in the foreground can now be made more precise with a series of brushstrokes that indicate their shape. This can be done with mixtures of raw umber, alizarin crimson, and ultramarine. The colors in this area should be rich and varied, as is indicated by a few dabs of pure emerald green.

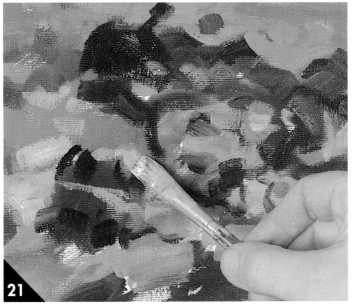

CLEAR STROKES AND BLENDING

When we talk about the impact of color, we mean the application of color without following an outline or mixing with underlying colors. Blending, on the other hand, means mixing one color with another on the canvas in order to make it fit in with its background or surroundings.

21 The lighter parts of the rocks can be painted with touches of various colors, depending on the way you see or interpret the scene. Some parts might be colored with straight ochre. Others could be painted a blend of this color, which is made cooler by mixing in a little ultramarine blue. The areas of sand between the rocks are wet, allowing us to alternate and partly mix the warm and cool tones.

22 The rocks are completed with a few strokes of cooler and very dark tones to give an effect of wetness. The color you can see on the brush is a mixture of ultramarine and a little raw umber.

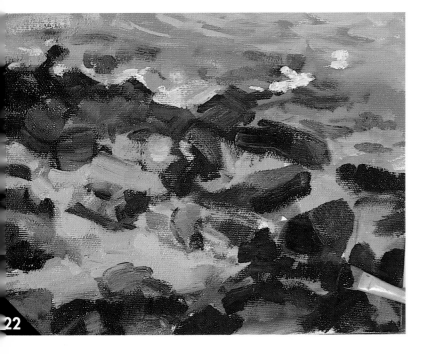

23 Here we have the finished painting. If you have followed our steps and used our advice, you should now appreciate that this subject requires a clear interpretation of the basic forms. The power of the painting comes from its decisive brushstrokes and overall chromatic unity.

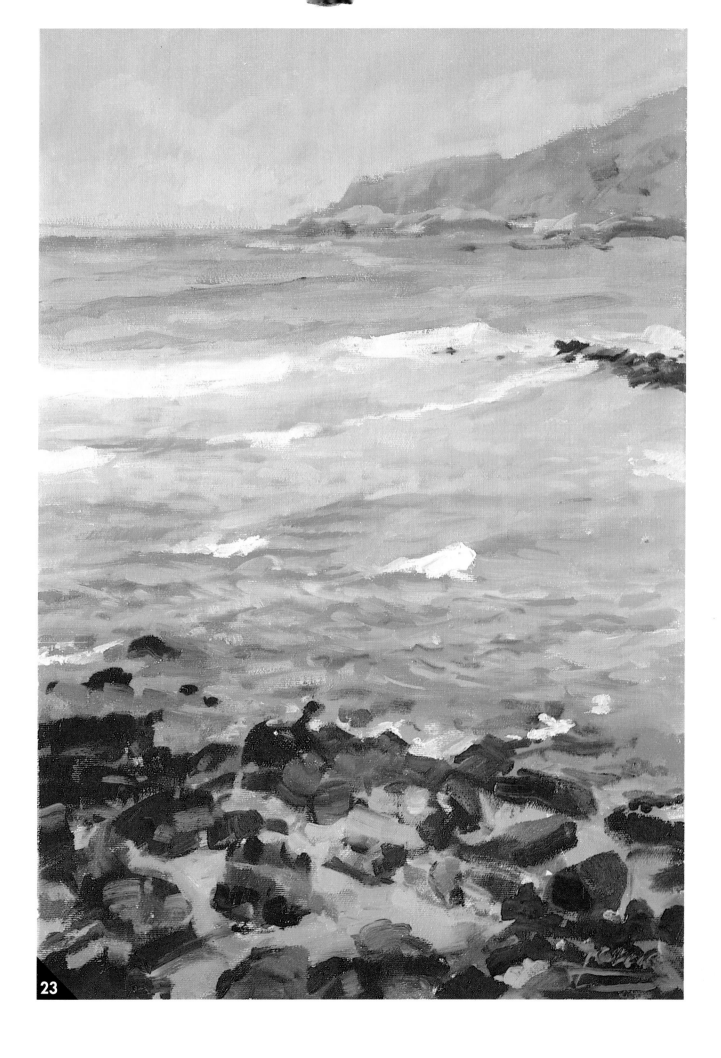

PAINTING THE SEA FROM THE BEACH

*T*he sea lacks the clear shapes that usually make up the composition of a painting. That's why most artists use features like boats or rocks to give their work a definite form.

The subject we are now going to paint does not make use of such features, however. It is based on the extraordinary beauty of the sea when seen from a beach in the early morning. You should find this exercise a lot easier than it looks, since its basic elements are the exquisite play of light and the general feeling of serenity that the scene expresses.

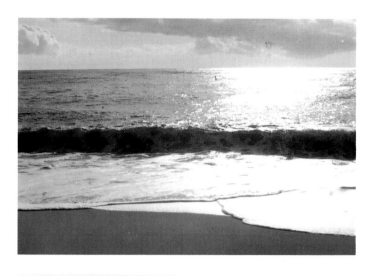

1 We have used a canvas colored with a dull red base that creates an immediate effect by offsetting the colder colors of our subject. We begin without any preliminary sketching, directly applying white for the light we observe in the scene.

MATERIALS

- Colored canvas on 21" × 26" stretchers
- Brushes: round bristle number 16, flat number 14
- Colors: titanium white, medium yellow, ochre, vermilion, alizarin crimson, violet, raw umber, turquoise blue, ultramarine, and emerald green
- The usual box and palette
- French-style easel

2 We establish the general color pattern as quickly as possible. The left part of the sea is ultramarine toned down with a little white and a dab of turquoise. These large areas are painted with a number 14 bristle brush for easier coverage.

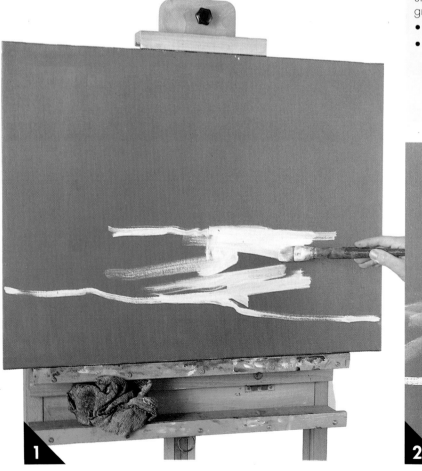

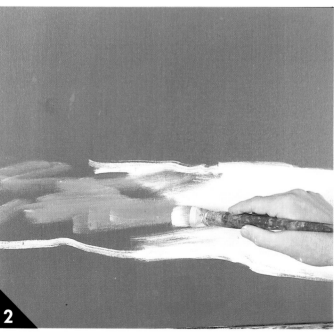

The shadow produced by the wave has a dark color obtained by mixing emerald green with a touch of alizarin crimson. The intermediate tones are achieved by partial blending.

The base color for this section of the sea is a mixture of ultramarine and turquoise, toned down with a little white.

The reflected light is painted with clear strokes of white, which are softly blended with a little yellow along the line of the horizon.

The dark area of the sky has a straight turquoise base with varying shades of violet. The lower areas have a neutral tone.

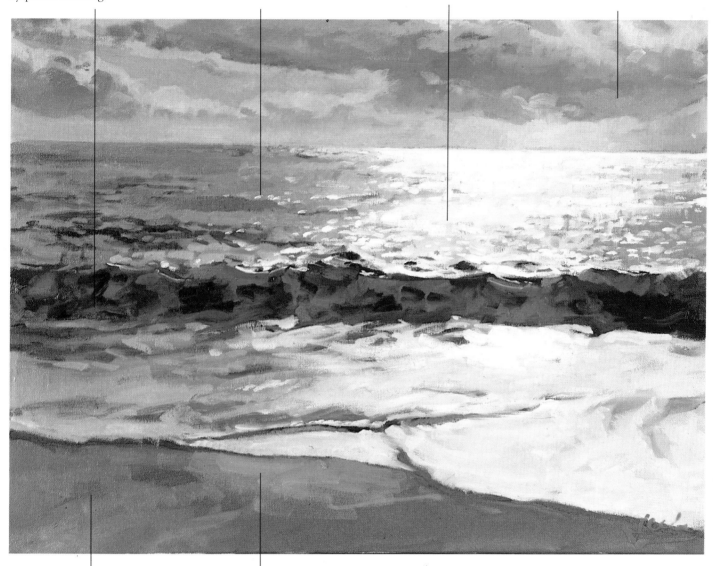

The color of the sand on the lower left side is virtually the same as the base color of the canvas, with a few touches of deep blue.

The reflection in the center of the sand is achieved by a partial blending of ultramarine and white.

3 The area corresponding to the surface of the sea is covered with a mixture of turquoise with a touch of emerald green. Make sure your strokes are vigorous and forceful and that they follow the general movement of the scene.

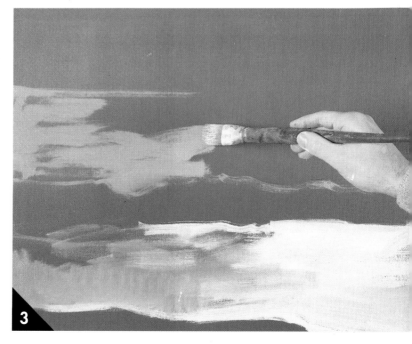

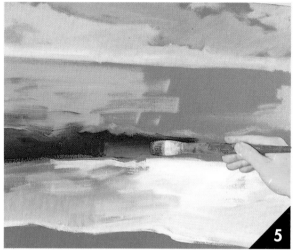

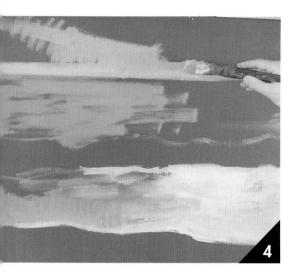

PREPARING THE CANVAS

A prepared canvas is one that you have first painted (an undercoat) with a mixture of colors from the ones left over on your palette from a previous painting. The tone should correspond to the subject you are going to paint. This will give greater texture and unity to the colors you use for the actual scene.

4 Now we paint large areas of color in order to cover the canvas. The tones are basic at this stage, since they will later be modified and detailed. Here we begin with the sky, indicating the horizon line with a mixture of white, turquoise, and ultramarine with a touch of violet.

5 Once the sky area has been covered with the initial flat tones, we use a much darker color for the shadow of the wave. Here the base color is a mixture of ultramarine and emerald green.

6 Now we paint the bright light reflected on the sea. To do this we use a basic white tone mixed with a little ultramarine and emerald green.

7 If we stand back at this point, we see how the work is beginning to express the feeling of the light. Note that our strokes have been clear, giving the painting a certain expressive rhythm. Of course, this has to be done quickly, since the particular play of light will not last for long.

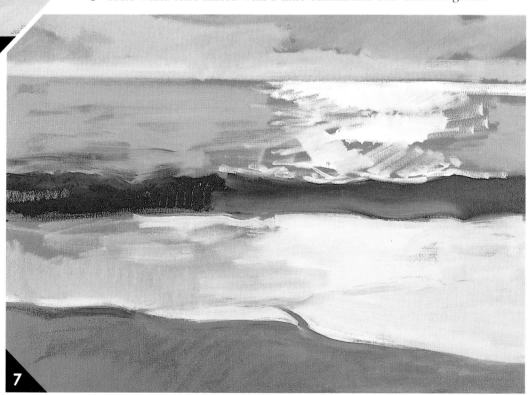

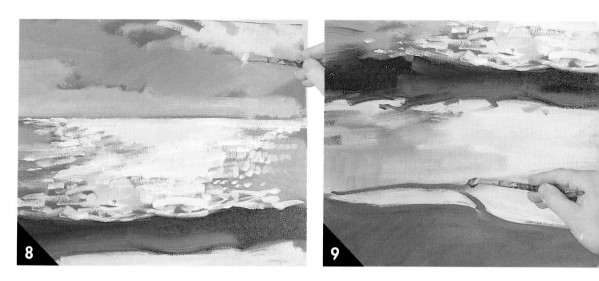

8 After a short break (not too long, since the light is changing all the time), we begin a second phase, adding more color and mixing new tones to enrich the depth and range of the work. For example, the upper part of the sky can be made a slightly lighter color, using a toned-down white.

9 Working from top to bottom, we mark in the lines produced by the spray from the waves. Use a mixture of ultramarine and emerald green. But don't forget that what counts is the effect of the work as a whole.

10 Now observe the shadow made by the wave. Despite the extreme contrast with the reflected light, the transparency of the water allows light to enter the waves, producing areas of more luminous color within the shadow. These lighter areas can be painted with straight ultramarine blue.

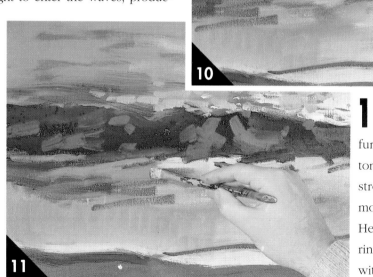

12 Now we return to the sky, opening new areas of light with a slightly warmer tone. The color is a mixture of white, ultramarine, and ochre.

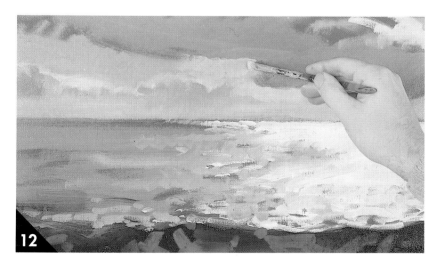

11 We continue adding color to the foam with further touches of different tones. Make sure that your strokes always follow the movement of what you see. Here we use a mix of ultramarine and turquoise, lightened with white.

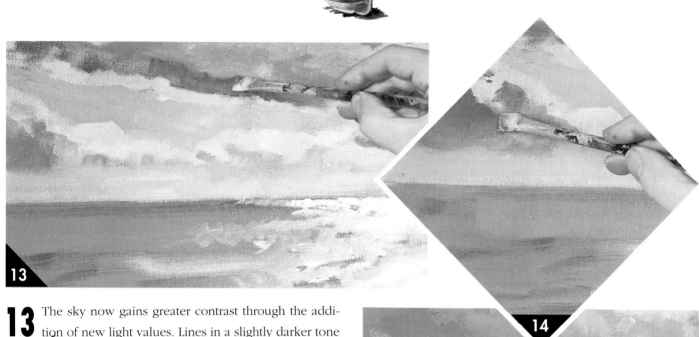

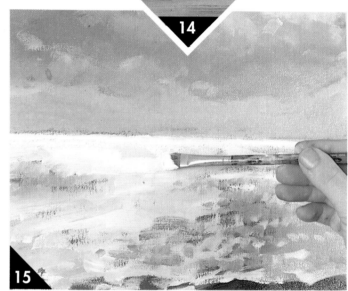

13 The sky now gains greater contrast through the addition of new light values. Lines in a slightly darker tone give greater volume to the bottom of the clouds. Use turquoise with a touch of raw umber.

14 The hard outlines of the clouds can now be softened with a mixture of turquoise and a touch of white. Note how the strokes here drag rather dry color across the surface, taking advantage of the texture of the canvas.

15 The reflected light can be strengthened in the area along the horizon. This is done with pure white mixed with no more than a touch of yellow. Good observation is needed at this stage. Make sure that every stroke is exactly where it should be.

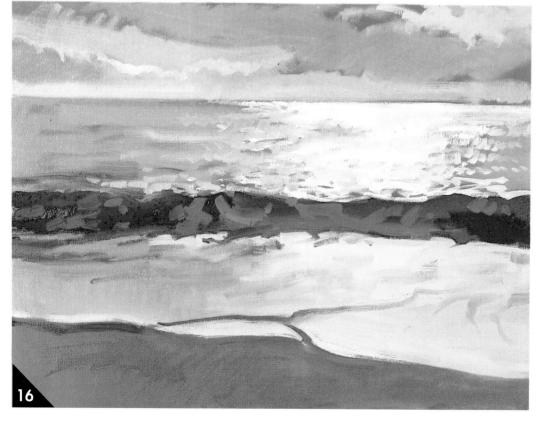

16 Standing back, we now see how the feeling of light has been achieved. Of course, the scene itself has to be made more precise and detailed. The sky has to be more unified and the rest requires greater precision. More work is needed to achieve the desired effect of light and serenity. So on we go!

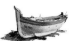

17 Now we start with the finishing touches. Observe closely how the various plays of light are produced, since they will lead us to greater realism. Details of the waves can be put in with a few strokes of white blended into the upper part of the wave's shadow.

18 Using turquoise and emerald green, we give greater texture to the area of foam. Note how the strokes here follow the rhythm of the water itself.

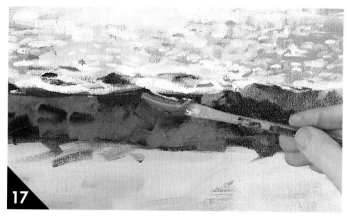

19 Perhaps the main feature in the foreground is the linear effect produced by the water moving in different directions. The general luminosity of this area is increased by darkening the upper parts with the same color as the one used to texture the foam.

20 This entire area can be colored with various shades of white, stroking the paint on and blending it with background colors on the canvas. Note how the white looks especially luminous where it contrasts with the color of the sand.

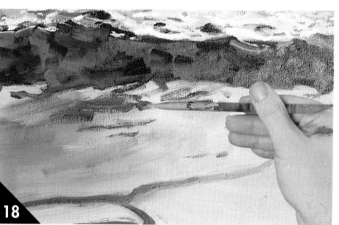

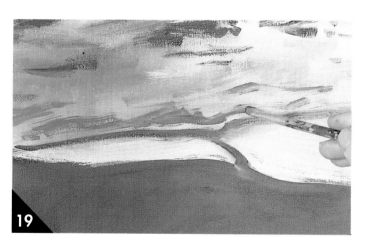

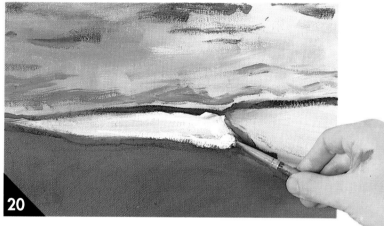

LIGHT STROKES

We have referred several times to brushstrokes that use "dry color." This means the strokes are applied lightly, without pressing down, so that the color stays on just the raised parts of the canvas or of the underlying paint. Since the stroke does not pick up the background color, the effect is a blending of tones within the texture of the canvas.

21 The right side of the foam area can also be painted with strokes of white, this time mixed with just a little violet. Since this tone is somewhat cooler, it balances perfectly with the area of light that we just painted with pure white, making the unmixed color look warmer and even more luminous.

22 We're now almost finished. But the light is changing so fast that once again we have to adjust our tones and values. A mixture of ultramarine and ochre adds light to the lower central part of the sky.

23 A mixture of vermilion and a touch of emerald green gives us a brick red color that can be blended with the bluish tones of the sand along the beach.

24 We continue painting the beach area, now with blue tones to create a sensation of the wetness of the sand in the parts just washed by the waves. Of course, these effects only last a moment, so we have to capture the image in the painting.

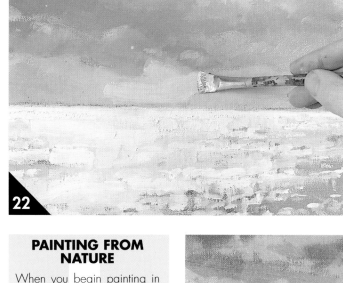

PAINTING FROM NATURE

When you begin painting in oils, you can do quite good work from photographs. But our advice is to work from nature whenever possible. The colors you see outdoors are far more lively, and the changes you observe will make your work fresher and more vivid.

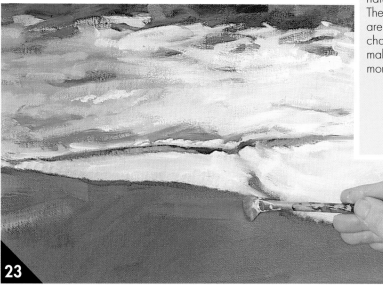

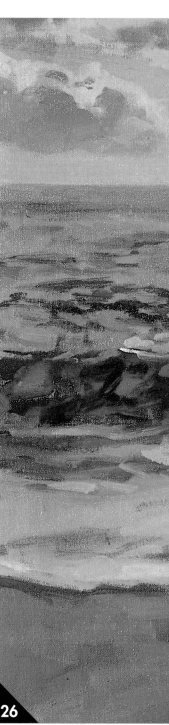

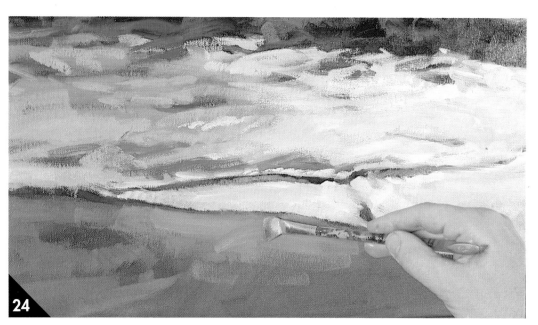

25 After a few last strokes of thick white to give the reflected light even greater strength and vigor, we can at last say the work is finished.

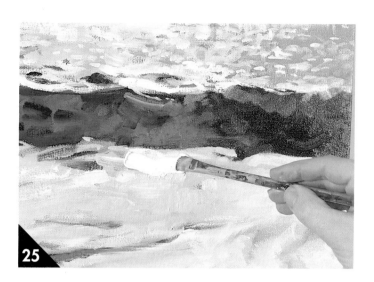

26 The time has come to stand back and judge the work as a whole. If everything has been done correctly, the scene should give the same feeling of peace and light that it suggested when you saw it for the first time. If this is so, the painting is finished.

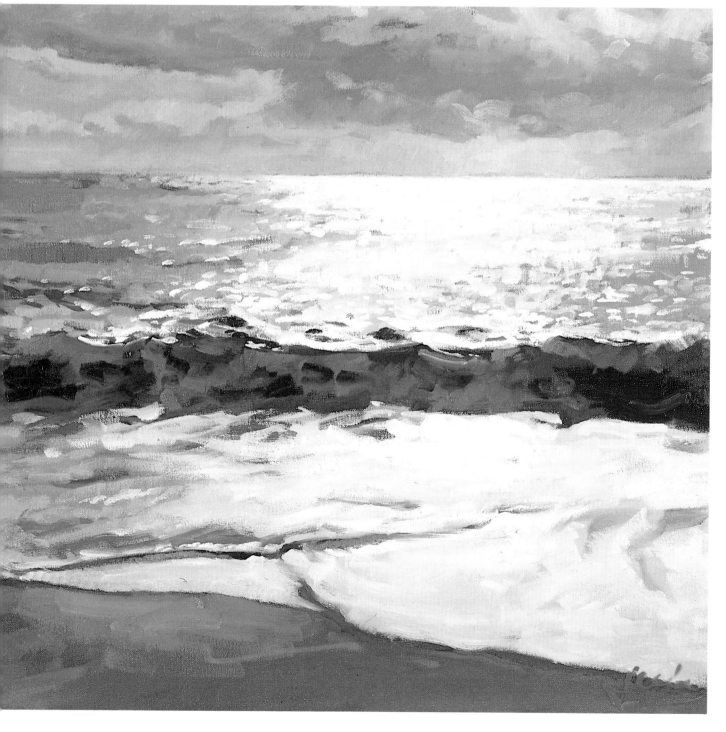

PAINTING THE FORCE OF THE SEA

*T*his time we have chosen a subject that expresses all the strength and power of the sea. This particular scene requires only that we reproduce the energy of nature.

First we spend a few minutes looking closely at the way the waves hit the rocks. Then we paint in an impressionistic style, capturing and interpreting the action through rapid brush-strokes.

MATERIALS

- White canvas mounted on 24" × 18" stretchers
- Charcoal sticks for drawing
- Brushes: flat synthetic number 12, round bristle number 8
- Colors: titanium white, medium yellow, ochre, vermilion, alizarin crimson, raw umber, turquoise blue, ultramarine blue, emerald green, and cobalt violet.
- Easel and equipment for outdoor work

The blue of the sky has been toned down by blending a mixture of tones. This helps bring out the purity of the blue in the sea and the white in the spray of the wave.

The hills in the background have been painted with a gray background color made by mixing alizarin crimson, emerald green, and a touch of white. The highlighted areas are painted with the same basic mixture, adding either ochre or more white.

1 When you go walking along the beach, always be ready to make quick sketches of what you see. If possible, carry a sketchbook and a small box of simple crayons or pastels.

2 We begin the actual painting with a charcoal drawing. This should follow the movement of the wave. But what interests us most at this stage is the general composition.

3 This time we use a white canvas, since white is the color that will dominate the waves in the center of the work. We begin with a general tone for the sky, made by mixing ultramarine, white, and a little turquoise. A wide brush makes the coverage easy.

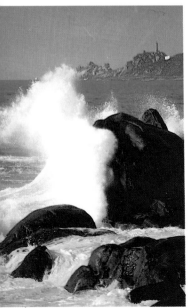

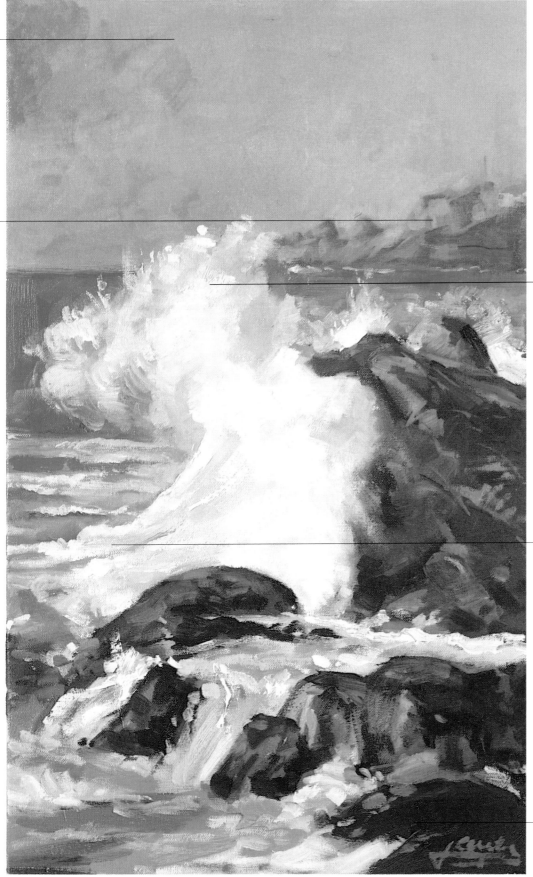

The spray has been suggested with short strokes of pure white over a background of softer whites mixed with blues.

The sea has been painted with very clear strokes of pure turquoise and light ultramarine. The horizontal lines formed by the crests of the waves are expressed by strokes of white.

The tones of the rocks are based on a mixture of raw umber and ultramarine, both with accents of emerald green. The lighter shades in this area have been made with orange and ochre tones.

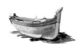

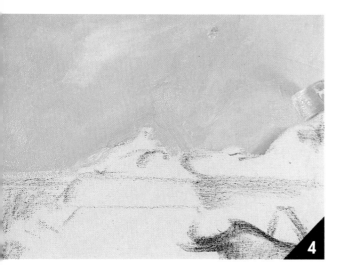

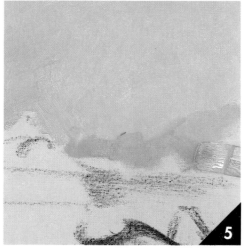

MAKING THE MOST OF MIXES

This page is a perfect illustration of how to make the most of the colors on your palette. Mixing should enable you to produce a wide range of harmonic colors in keeping with your base color. It's also very easy to use the same color twice, simply by mixing it with a slightly different tone.

4 Now we complete the general background color of the sky, using a flat brush and a mixture of white, turquoise, and ultramarine.

5 The same brush can be used for the hills in the background. Here we use the same color as the one for the sky, mixing it with a little alizarin crimson.

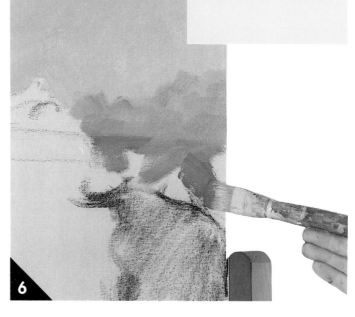

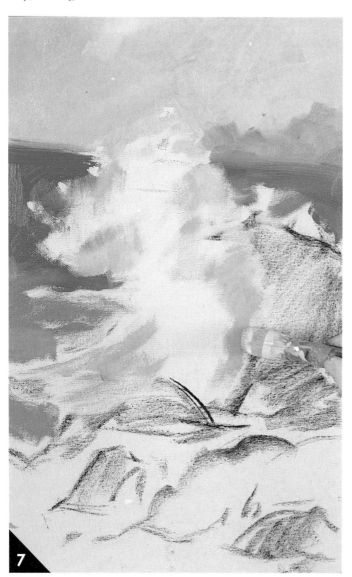

6 By adding ultramarine, we make a good base color for the sea. Note that this is only the first color. Others will be painted over it later.

7 The darker areas of the spray are suggested by a base color obtained by mixing the color used for the sea with a little turquoise. As you can see, the same brush can be used for all these initial steps.

8 Remember that you must work quickly to ensure that the painting has a general tone, especially when working on a white canvas. Once we have finished the blues, we start on the darker colors of the rocks, using straight raw umber.

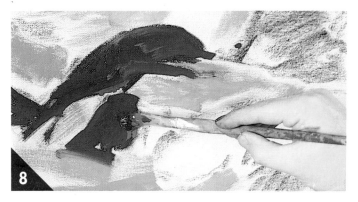

9 We continue with the rocks, putting in slight color variants. The photo shows one of these variants, made by blending ochre with the base color.

10 In a very short time we have produced a general color scheme, using broad strokes and basic tones that will be enriched later with other colors. You shouldn't be afraid of the canvas. Proceed with very bold strokes. There will be plenty of time later for whatever modifications and details are necessary.

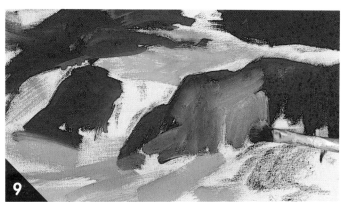

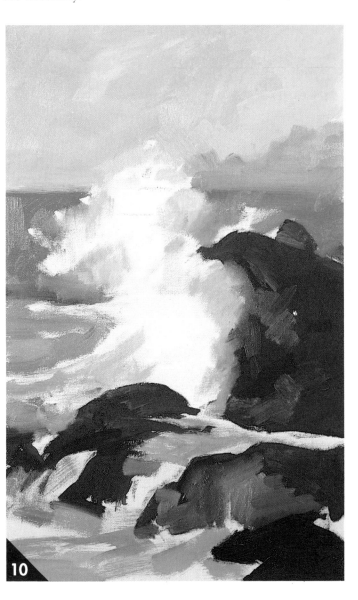

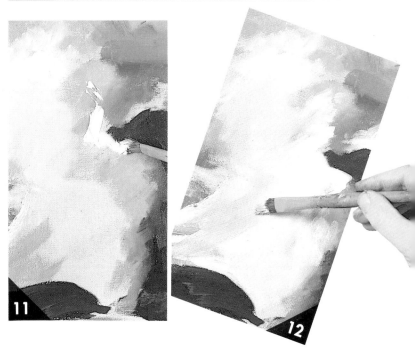

11 Now we go back over the work to bring out as much light as possible where the wave crashes against the rock. The photo gives you a good idea of how strong the pure white is in relation to the base white of the canvas.

12 We put down the large brush and begin with a finer one, which allows us to express more precise forms. We continue to vary the white by adding turquoise and ultramarine, in order to blend the lower part of the wave with the sea.

13 The spray is further painted with very clear bluish tones. Here we have used ultramarine and turquoise mixed with a little white, applied with a soft synthetic brush that is much finer than the one we started with.

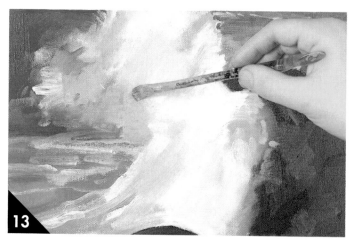

14 We return to the bottom of the spray, still with very clear tones. Note the luminosity and clarity achieved by these strokes of turquoise and white. A good observer should be able to place each stroke in keeping with the general rhythm of scene, working with delicacy and decision.

15 Here we have another overview of the work, showing how the general appearance of the spray has been developed and defined. We have also begun on the white of the water splashing over the rocks.

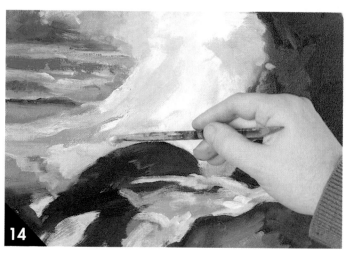

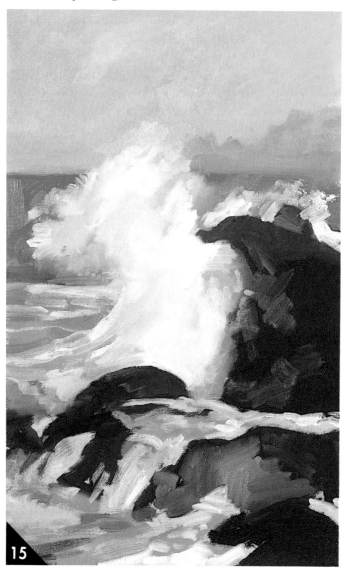

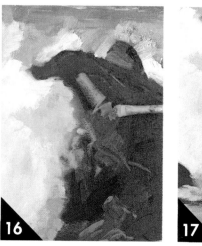

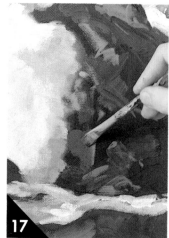

16 Without spending too long on the colors of the sea, we move on to the lighter colors of the rocks, expressed with a few clear strokes of ochre.

17 Greater character is given to the rocks by adding further color variations. Here the ochre has been mixed with a little ultramarine and alizarin crimson, giving a cool neutral color that harmonizes with the color of the spray.

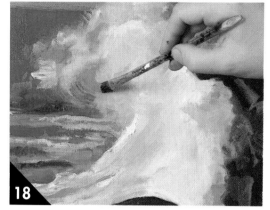

18 Now we go back to the spray, putting in some accents of pure white at the crest. At this stage each stroke has to express direction and character.

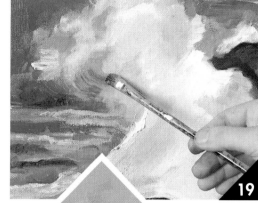

19 The touches of pure white are now toned down by blending. Their shadow is indicated by a few carefully placed curves in emerald green, which are half blended with the background colors.

20 Each stroke obliges us to give even more emphasis to the areas of light and volume. This effect is achieved by adding some strokes of pure white to the left side of the central spray.

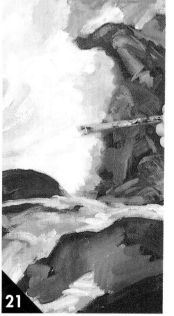

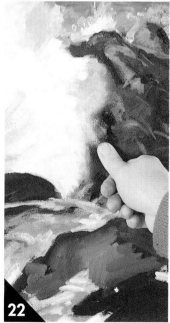

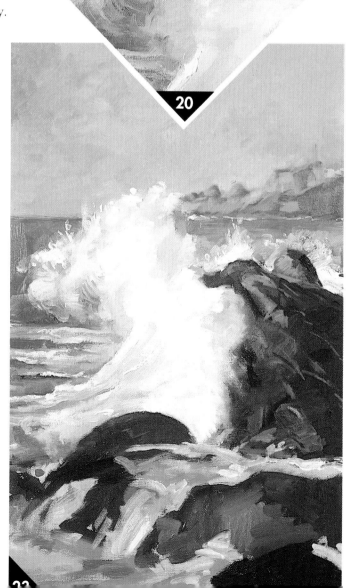

21 Using the same technique, a few clear strokes bring out the light in the lower part of the spray.

22 Putting down your brush, you can even do some delicate blending with your thumb. Since the base color of the rock is now almost dry, the white can be rubbed over the top of it.

23 Now we stand back and look at the whole work, which is almost finished. Note how the strokes of pure white have captured the force of the wave as it crashes

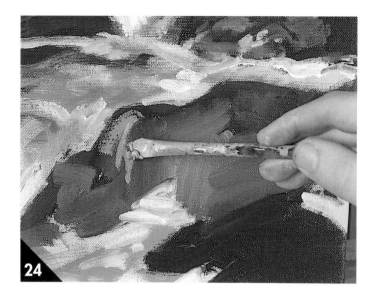

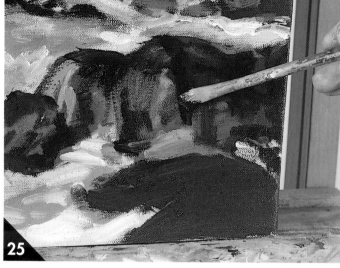

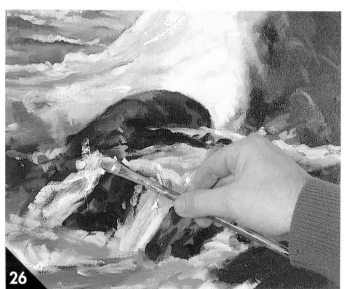

24 It's time to add details to the foreground. The areas of light can be expressed with clear strokes of pure ochre.

25 We give greater volume to the rocks by using a strong dark color obtained by mixing raw umber and ultramarine. A few very light strokes across the top of the canvas give some very effective color highlights.

26 Note that the water foams as it runs through the rocks. This can be expressed by a few strokes with a brush full of pure white.

27 The dark areas of the rocks require a few variations of color. In this case we have used strokes of unblended ultramarine and turquoise to balance with the areas of warmer light.

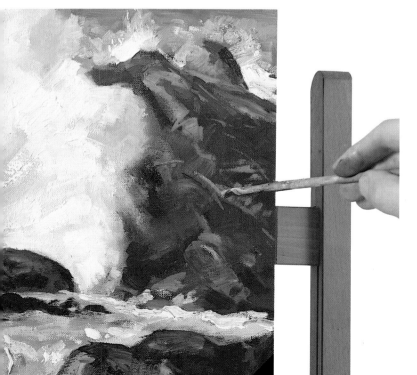

HOW TO USE BRUSHES

Each time you change the basic color you're working with, or when you go from warm to cooler tones, make sure you clean your brushes properly. This is to keep one set of colors from dirtying another. Many painters solve this problem by reserving one brush for each color range.

28 This painting took about three hours to complete. The aim was to make sure that each stroke had enough character to express the general qualities of force and vigor. If you have followed the above steps, you should have captured much the same qualities.

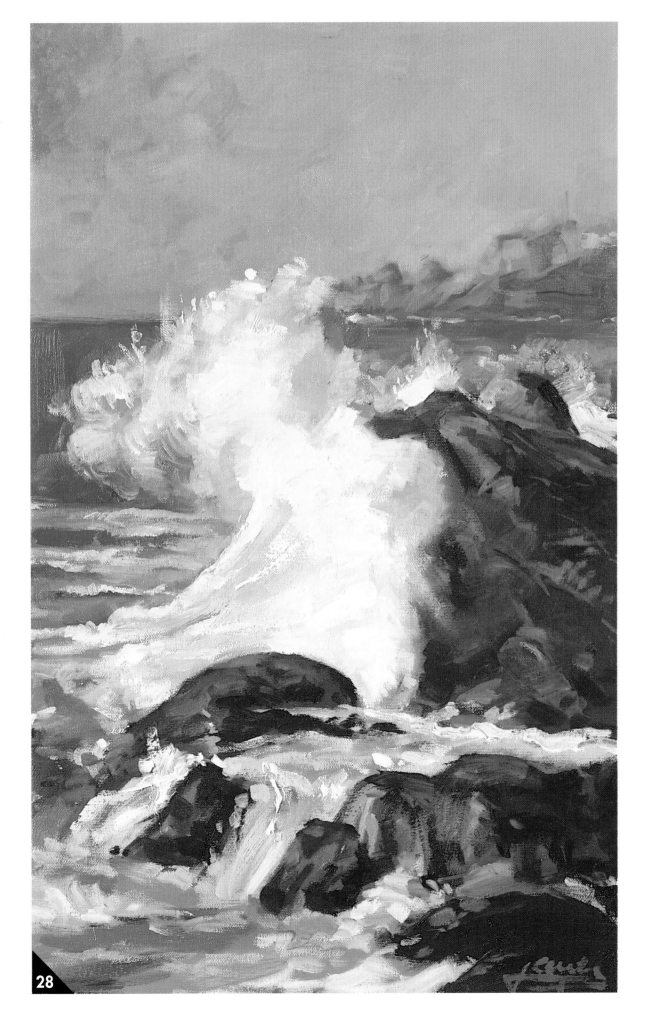

28

PAINTING A LARGE ROCK

*T*he rock shown in the photograph is known as "Roca Grossa" in Catalan, which literally means "Big Rock." This rock means a lot to me because I first painted it when I was a child just beginning to paint. I remember standing in front of it and receiving advice from several adult painters, to whom I am now very grateful. So you can understand the emotion with which I now return to the same scene. I'll try to remember and pass on some of the advice I received so long ago. I only hope you will experience a little of the pleasure this painting has given me.

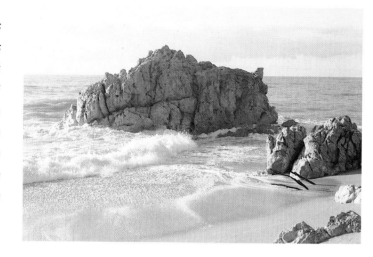

MATERIALS

- White canvas mounted on 24" × 20" stretchers
- French-style easel
- Brushes: flat bristle number 14, round bristle number 8, flat synthetic number 12
- Charcoal for drawing
- Colors: titanium white, medium yellow, ochre, orange, vermilion, alizarin crimson, cobalt violet, turquoise, ultramarine blue, emerald green, and raw umber

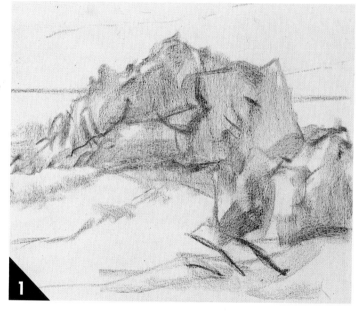

1 We first sketch the basic forms with charcoal, placing the forms on a horizontal canvas. As you can see, the compositional features are mostly on the right, leaving room for the waves and the spray to become important. The central rock is so well known in this part of the world that it tends to be too familiar to me. I constantly have to look at it closely to make sure I appreciate its structure.

2 In this case the charcoal drawing has already indicated the main areas of light and shade. Now we start the painting with the dark tones that are going to stand out against the light of the sky. The rock is painted with a mixture of ochre and ultramarine, thinned with a little turpentine. I suggest adding a little drying agent as well. Note how the strokes here follow the outer lines of the shadow.

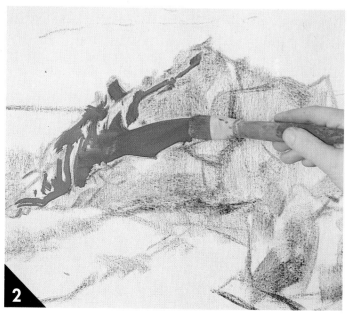

The luminous area of the sky has been expressed with soft bluish tones. The lower area has been painted with a mixture of white, ochre, and just a little ultramarine.

The lighter areas of the main rock have been suggested with various strokes of pure color, starting with pure white and then mixing it with a little ochre and blue.

The dark part of the rock has a base color made by mixing ochre and ultramarine. The areas of reflected light have touches of turquoise, violet, and orange.

The soft cloud in the sky has been painted with the background color (a mixture of white, turquoise, and violet) with some warmer shades made by adding a touch of orange to the mixture.

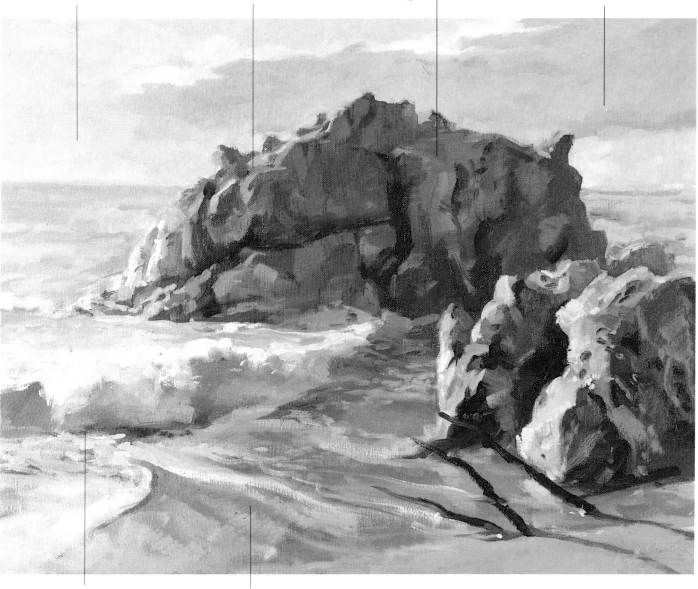

If we observe the shadow of the wave closely, we find various touches of color on a base of neutral gray, obtained by mixing raw umber with turquoise and a little white. Where the water appears clear and luminous, it is painted with a mixture of white and ultramarine.

The darker areas of the receding water are a mixture of raw umber and turquoise lightened with a little white. The texture of the spray is suggested by strokes of white and violet.

3 As you can see in the photograph, we add a little turquoise to the base color. Here we use a number 14 brush for the broad strokes required to cover the area, making sure each stroke has direction and character right from the beginning.

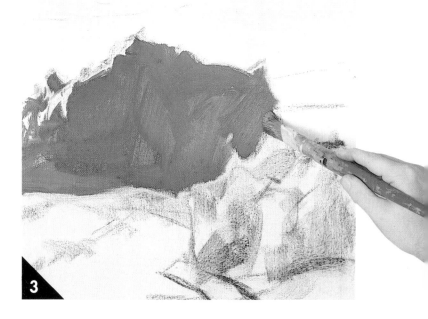

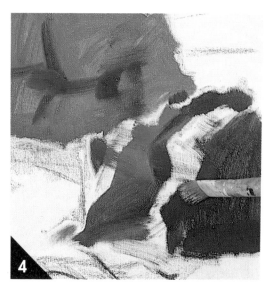

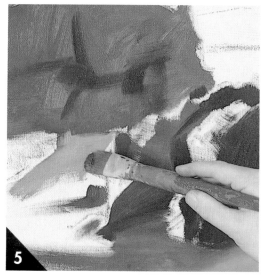

5 We are painting so quickly that the color we used for the rocks can now be used for a few strokes following the direction of the water. It is also a good tone for a section of the beach, with the addition of a little ochre. The base color of the water is a mixture of turquoise, ultramarine, white, and just a touch of raw umber.

4 Now we go to the foreground, putting in tones that are darker and warmer. This is done by adding alizarin crimson and raw umber to the mixtures used previously. Note how the strokes here follow the dark area that will contrast with the light.

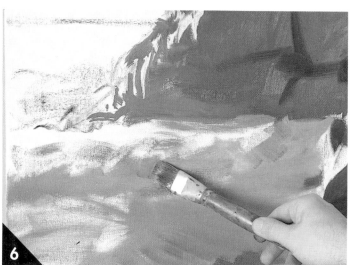

6 Now we quickly paint the areas that give a first impression of the wave and its meeting with the sand. This really means bringing out the light by painting the darker areas.

USING A DRYING AGENT

Cobalt drying agent is a product that makes oil colors dry faster than usual. But use it sparingly; in large doses it dries out the color and can lead to premature cracking. Add just a little to your paint mixtures, and make sure you also add some turpentine.

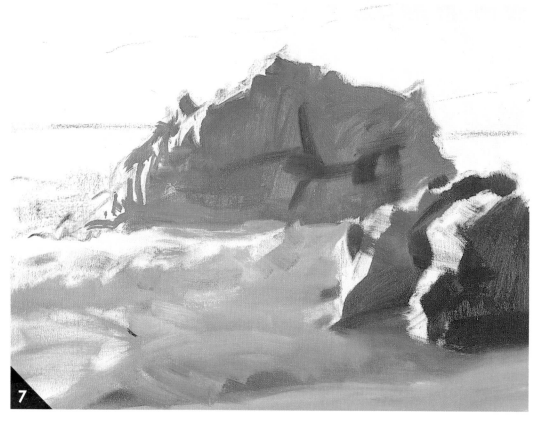

7 Since we're painting straight from nature, the light we see is changing all the time. That's why we have had to work quickly to capture the particular areas of light and shadow that we want to depict.

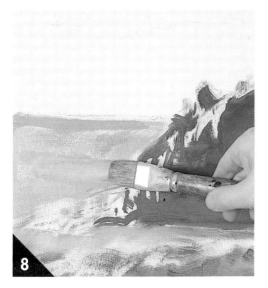

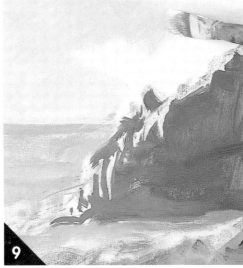

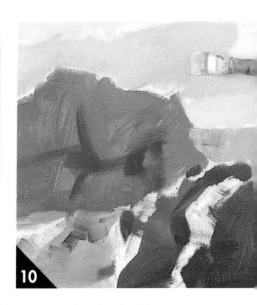

8 Now we fill in the sea area, without covering the white that corresponds to the spray. The general color here is a gray-blue obtained by mixing ultramarine, white, and just a little umber to break the clarity.

10 A few further strokes suggest the cloud with a tone formed by adding ultramarine and a touch of violet to the base color of the sky.

9 The sky can now be colored with turquoise and white, basically to attain an overall impression as quickly as possible. These intermixed tones harmonize with those of the rest of the scene.

11 Now we go back to the rocks in the foreground to paint the general color of the highlighted areas. This can be done with straight ochre, using a synthetic brush just a little finer than the one used up to now.

12 The ochre of the rocks is now lightened with white, and we put in the lighter area of the main rock. Since we're still at the stage of giving a general feeling to the work, each stroke should express direction and rhythm.

13 The most intense light is at the top of the rocks. This is expressed by adding more white to the color used for the other light areas, then applying the color quite heavily and directly.

14 Further features of the rocks can now be defined. To begin this process, first put in the darker cracks with raw umber, using a round bristle brush.

15 The rock has quite definite features that need to be shown with considerable precision. A few touches added to the violet tone of the sky help give the rock a more exact outline.

16 When we first put in the background colors, we didn't use the strong tones that can now be used to define the details. Here we indicate further lines in the rocks in the foreground, using a strong dark tone made by mixing violet and emerald green.

MAKING BRUSHSTROKES EXPRESSIVE

At the risk of repeating ourselves, let us once again insist that each stroke must be in a certain direction. This gives the work rhythm and character, helping to knit together a general impression of the object. Make sure your strokes model the object. Your work will be all the more expressive as a result.

17 The foreground rocks now need greater luminosity to show the light reflected when they are wet from the spray of the waves. These effects can be expressed by a series of clear strokes of pure white.

18 The sky is now further defined with more subtle color variations. The upper part of the cloud is indicated with a few soft strokes of white. The center area can be toned with the addition of just a little alizarin crimson, as shown in the photograph.

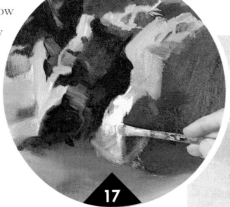

19 We're now ready to start with the finishing touches. This means painting new tones over the base colors. In the photo you can see how we soften the shadow of the wave and reinforce its character with a mix of ultramarine, white, and a bit of violet.

20 The direct strokes of white that we apply at this stage are not just to cover the original canvas. The direction of the strokes and the thickness of the color also give a vigorous luminosity that expresses the crest of the wave.

21 Here we have a new overview of the entire work. As you can see, the various features are gradually taking shape. But now we have to capture the effect produced in the foreground by the water as it flows back into the sea.

22 Using the side of a synthetic brush and straight raw umber we put in the form of three old pieces of wood that are stuck in the sand. These strokes should leave the color on top of the base, without any blending with the underlying tones.

23 As the water flows out and is absorbed by the sand, it produces a complicated series of reflections. These can be painted with a mixture of white and violet, letting the brush skim across the top of the canvas.

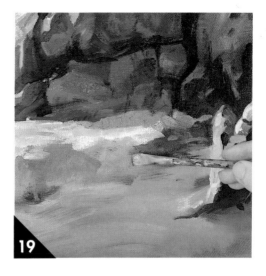

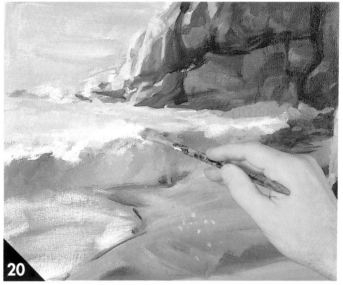

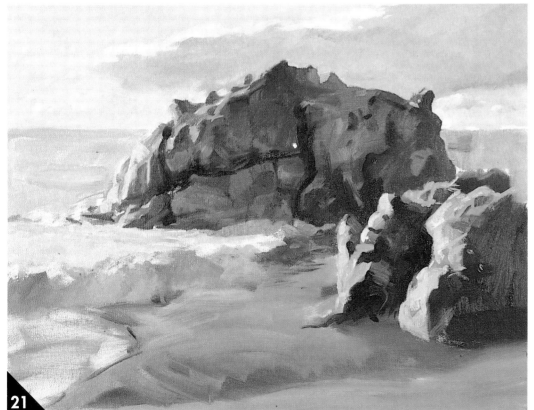

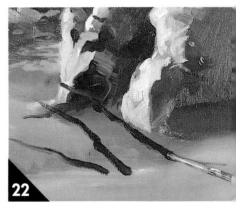

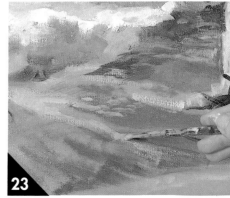

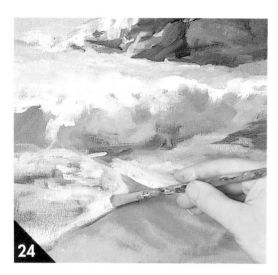

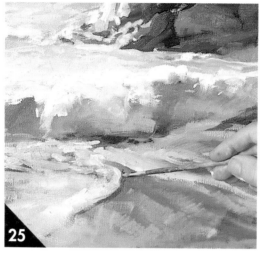

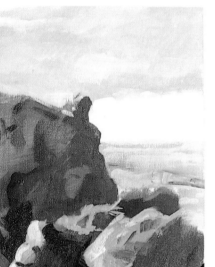

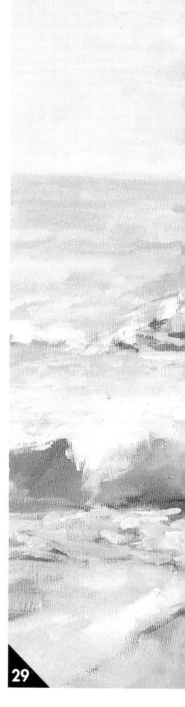

24 The same mixture of white with a little violet is now used to give shape to the small receding waves that are making way for the main wave.

25 A few light strokes of pure white add more light to the crest of the wave. Of course, the waves change so fast that we can only give an interpretation of the object.

26 While we've been painting, the light has been strengthening the colors of the sea. The tones in the area to the right are now much purer and can be given more luminosity by adding a turquoise tone.

HOW TO OBSERVE A SCENE

Before beginning a seascape, it's a good idea to look at the scene with your eyes half-closed. This is an easy way to get an idea of the general composition and color scheme. You can see everything as a whole, the volumes and areas of light have greater substance, and you learn to see tonal values rather than independent objects.

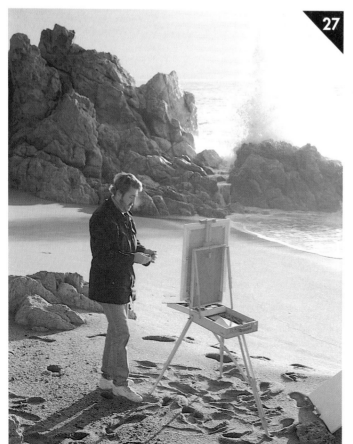

27 We are now at one of those difficult moments when we have to decide if the work is finished or not. Self-criticism is always a complicated affair. But you should look very carefully at your painting to check that there aren't any areas where a few final touches might improve it.

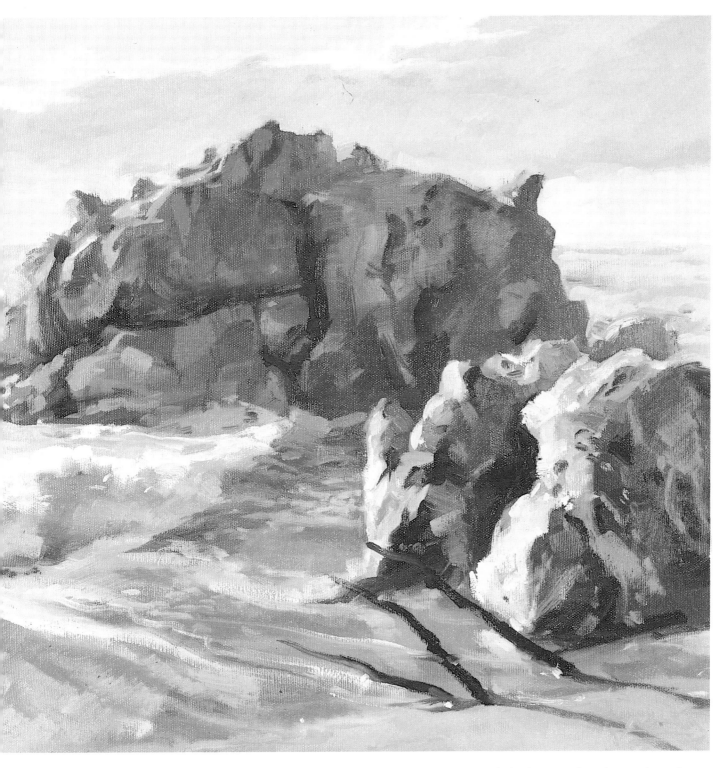

28 The stronger light has produced a series of pronounced reflections along the side of the main rock. Since this effect undoubtedly improves the overall painting, we express it with a few clear strokes of pure white.

29 At this point I decided the work was finished. The light had already changed the tones so much that it would have been risky to continue much longer. The main point was to express the movement of the sea. If you've been able to do the same, congratulations. The task is by no means easy.

PAINTING A GROUP OF MOORED BOATS

O *ur subjects are gradually becoming more complex. The form of these moored boats requires a lot more care and attention than our previous compositions. The shape of each boat is made difficult by a downward-looking perspective that has to be drawn correctly. Any error in the initial composition will lead to serious problems later, especially when there are so many elements involved. But if you follow our notes, a good result is guaranteed.*

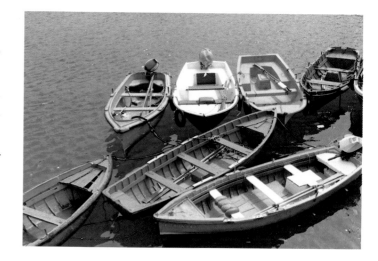

1 The initial sketch must place all the elements in relation to each other. See how the boats in the foreground are horizontal to the viewer, in contrast to those at the back, which face us directly. Once the drawing is finished, remove the excess charcoal with a clean rag.

MATERIALS

- White canvas mounted on 32" × 25" stretchers
- Charcoal stick for drawing
- Brushes: flat bristle number 14, round bristle number 8, flat synthetic number 14
- Palette and French-style easel
- Colors: titanium white, medium yellow, ochre, vermilion, alizarin crimson, raw umber, violet, turquoise blue, ultramarine, cadmium green, and emerald green
- Turpentine and cobalt drying agent

2 The first strokes of color here are painted in a strong dark tone made by mixing ultramarine and alizarin crimson, applied with a bristle brush.

3 Continuing with the same color, we paint the darker areas to create a first impression of the overall forms. Of course, this general color will be modified later.

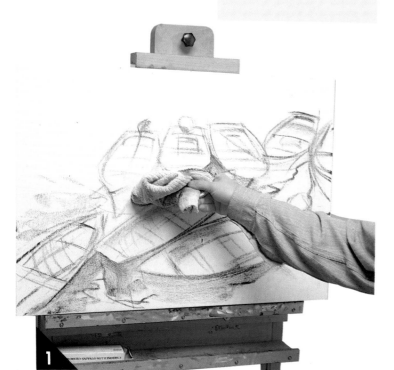

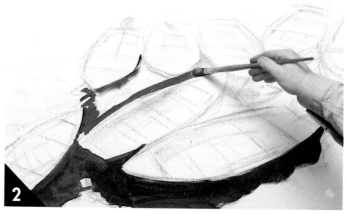

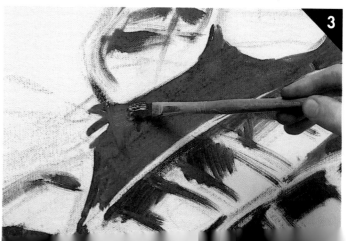

The basic color of the sea is a mixture of ultramarine, turquoise, and a touch of white. The light effects in the area to the right have been emphasized by adding more white to the mixture.

The base color of the boat on the left is ultramarine blue, painted in varying intensities.

The second boat is based on a warm white, with the shadows painted in a mixture of white, ultramarine, and a touch of ochre to give them a more golden tone.

The shadows under the boats are basically a mixture of dark ultramarine and a little alizarin crimson.

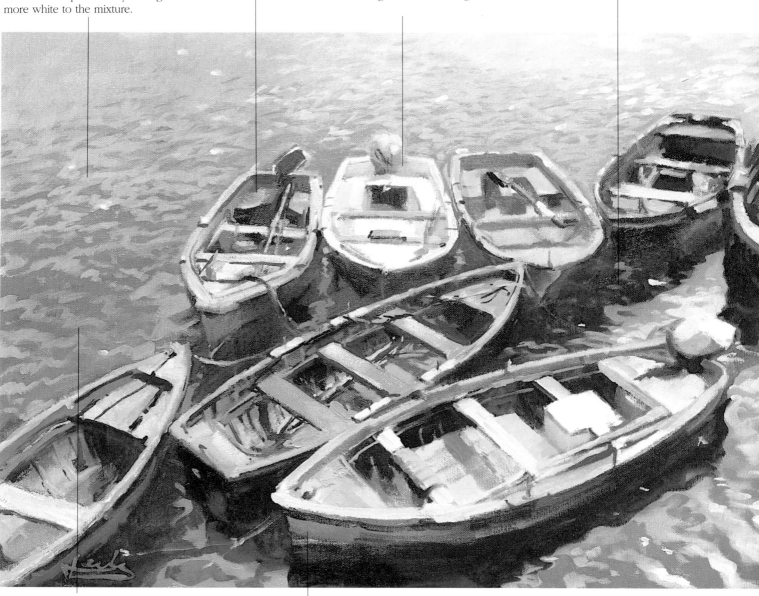

The darker tone of the sea is a mixture of ultramarine and emerald green. This helps to suggest the ripples of the water.

This reddish boat has been painted with vermilion, a mixture of alizarin crimson and white, and additional touches of ochre for the warmer areas.

4 The basic color used for the shadows under the boats is now applied to the sea, but with the addition of a little white, some turpentine, and a touch of drying agent. All these strokes must be confident and quick, since our aim is to cover the canvas as quickly as possible.

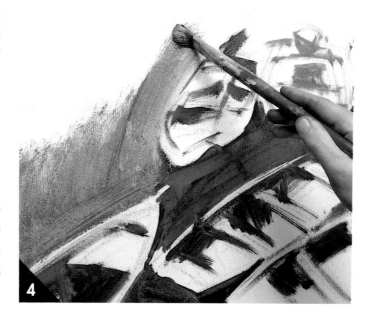

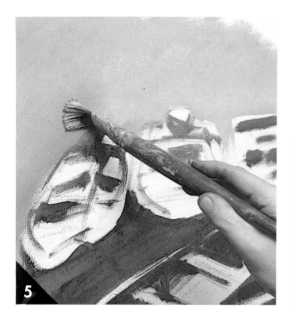

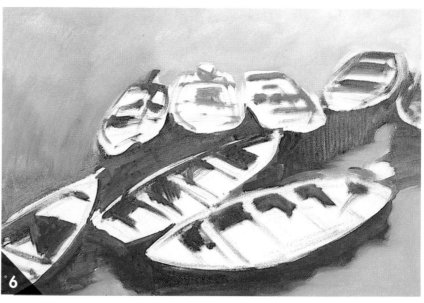

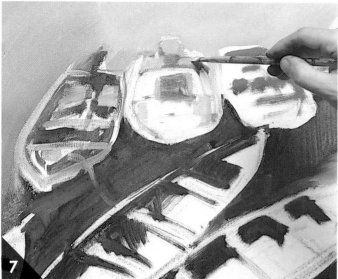

5 The sea area is now completely painted, carefully but decisively. By diluting the base color with white and a little turpentine, you can cover the canvas quite quickly.

6 With just a few color variations we have completed the first stage of the work in a very short time. You should make sure to cover any remaining white canvas as soon as possible.

7 We now paint the individual boats. The areas of shadow inside this particular boat are painted with variations of ochre mixed with white and a touch of raw umber.

8 The boat on the left is painted with a mixture of ochre, ultramarine, and white. The photo shows one of the lighter areas being painted. These areas should enhance the general overview of the work.

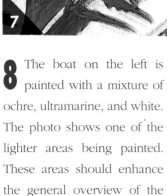

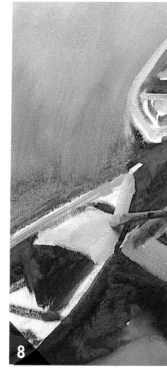

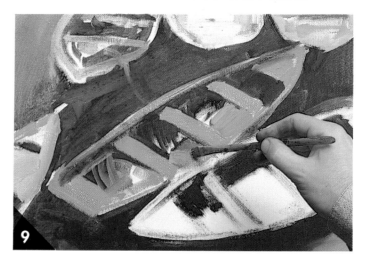

9 A few strokes of pure orange enrich the basic color of another boat. Even though these strokes are applied quickly, they should blend in perfectly with the form being depicted.

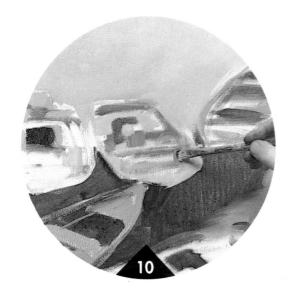

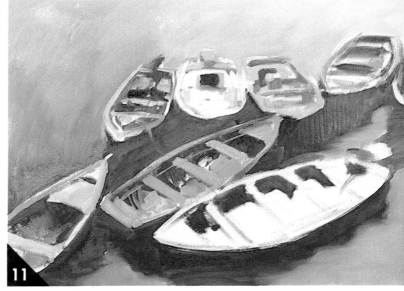

10 A few strokes of pure vermilion accentuate the luminosity of one of the boats. Don't be afraid to work quite freely here, without worrying too much about the details.

11 Here you can see the general development of the color scheme. Our aim has been to indicate the general tones as quickly as possible.

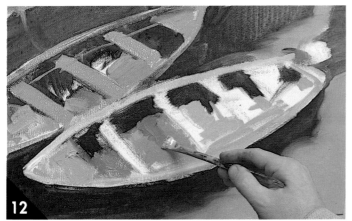

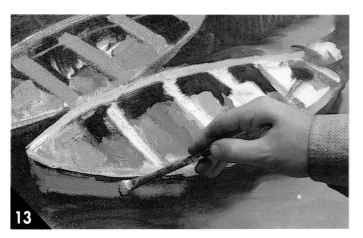

12 Now we tackle the main boat in the foreground. We start with a range of warm colors. The one being applied in the photo is pure vermilion, which is then blended with the background colors.

BASE COLORS AS A GENERAL IMPRESSION

When we cover the canvas with color, lay in the background color, we always keep in mind the details of the composition. If you look at the scene with your eyes half-closed, you will see how the details become unimportant and the large shapes become areas of color. The scene will also have a general color range that can be painted quickly, even though later on the background colors have to be modified.

13 The same vermilion is used for a few clear strokes along the side of the boat. These strokes are by no means detailed, but they should always follow the direction of the form.

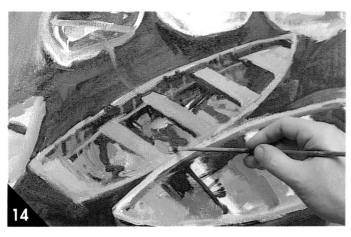

14 Now we can begin with a few details. Here we add a few strokes of ochre and orange to the second boat, giving warmer tones to the base color and enriching the overall impression.

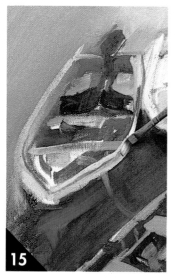

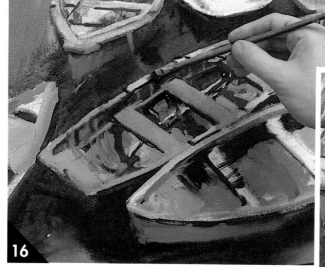

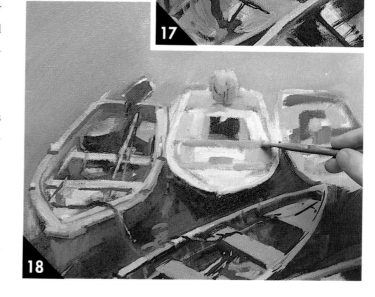

15 The shapes of the boats are now painted in greater detail, using a narrower brush for the lines and details. We begin by outlining one of the boats with a mixture of white, ultramarine, and turquoise.

16 We continue to emphasize the highlighted silhouettes of the boats. White mixed with ochre is used to indicate the fixtures used to attach oars.

17 Of course, the boats are quite complicated to paint, with countless details that now have to be suggested. Here we use the side of the brush to indicate the moorings with ochre and white.

18 The seats of one of the boats are painted in a grayish violet tone made by mixing white, violet, and a touch of emerald green. This color blends perfectly with the ones around it.

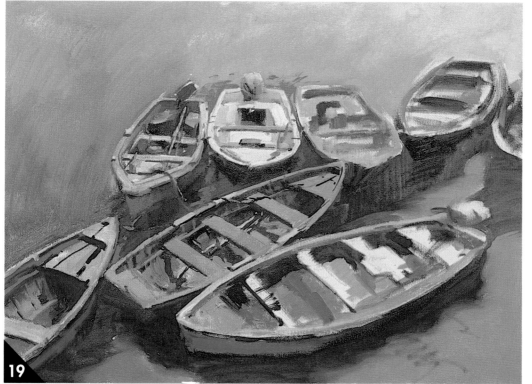

19 Here we have a new overview of the work. Compare it with the previous one (step 11). Our attention to the forms now gives an impression of far greater detail.

20 Each boat is now painted, paying special attention to the effects caused by the light falling from almost straight above. Here we use a mixture of orange and white for one of the highlighted areas.

21 A gentle breeze makes the boats rock a little, producing ripples in the water. This effect is suggested with a mixture of turquoise and white.

22 Now we give greater texture to the water. The shadow produced by the movement of the sea is painted with emerald green mixed with a little white. Apply each stroke carefully, making sure that it follows the actual movement of the water.

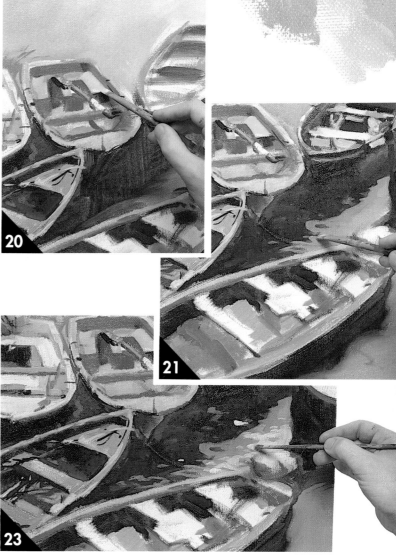

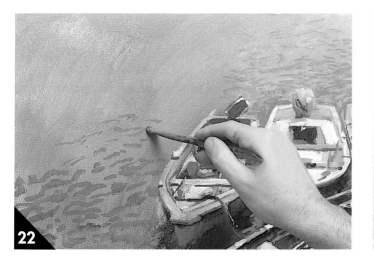

23 Time is moving on, and the light is becoming stronger. Now we can see some reflected light sparkling on the water between the boats. A few clear strokes of pure white suggest the effect.

24 Now we're ready to begin the final stage. So far, the details have been painted in an impressionistic style, becoming increasingly clear the more we work. But we still have to do the details in the foreground.

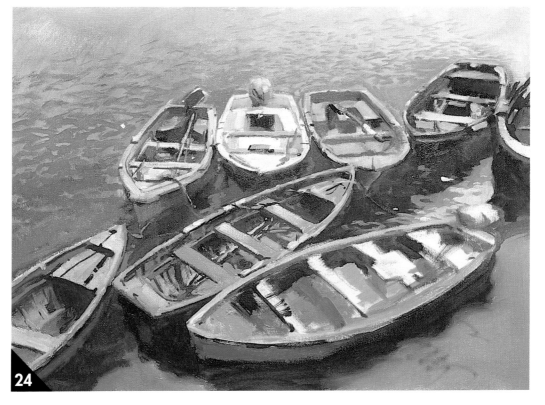

25 We start on the foreground by going over the colors and details of the main boat. A few parallel strokes give the effect of the boards at the bottom. The color here is a mixture of white, vermilion, and a touch of ochre.

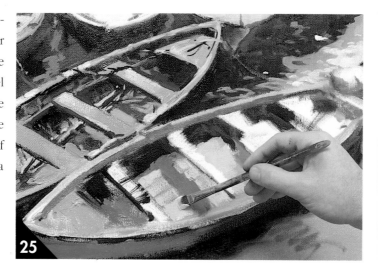

CLEANING BRUSHES AND PALETTES

Before changing from one color range to another, be sure to give your brushes a good cleaning with turpentine, then dry them with a rag. This is to prevent the new color from being changed or muddied through contact with another color left on the brush. You should also clean your palette with a rag or a paper towel whenever it becomes so full of paint mixtures that you no longer have space to produce clean colors.

26 The details in the foreground should be a little clearer than the rest. Here we paint the oars with the side of a medium-size brush. The color is a mixture of white and ochre.

27 The boat is now finished. Pure white has been used for the seats and the motor, with the addition of a little raw umber for the corresponding shadows. The ripples in the water are painted with a mixture of turquoise and a touch of ochre.

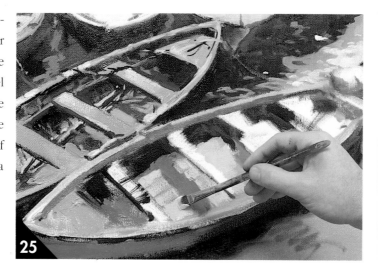

28 The points of reflected light can now be interpreted with a few strokes of pure white. Once again, we make sure that each stroke emphasizes the form we are looking at.

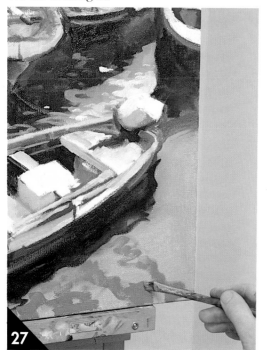

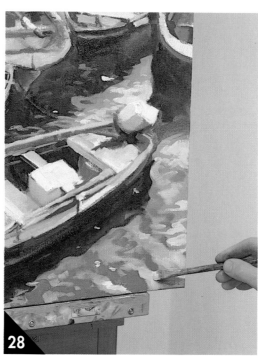

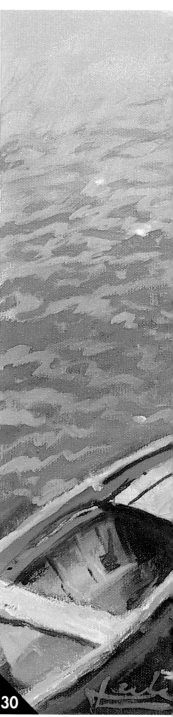

29 We now go over the light reflected on the surface of the water, adding form and texture with a mixture of turquoise and a little violet and white.

30 The finished painting. The most difficult part was putting in all the details and developing the wide range of colors needed for each boat. As we said at the beginning, complex forms require great care and attention.

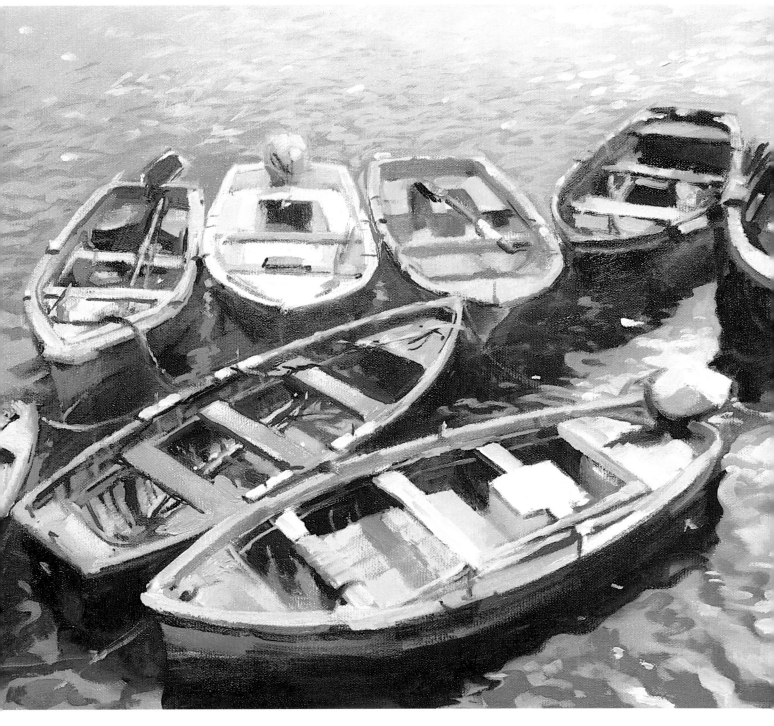

PAINTING A PORT SCENE

O *ur final exercise is a classic subject. It's a group of boats of the sort one often finds in a small fishing port. The scene requires a careful sketch with the correct use of perspective, a feeling of depth between foreground and background, and skill at reproducing the effect of light produced by the reflections on the water. All these features will help consolidate what you have learned so far and enable you to develop your skills even more.*

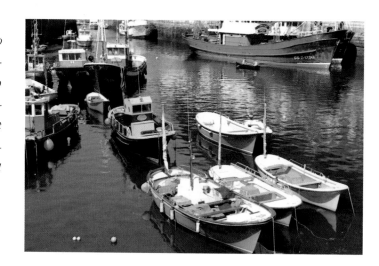

MATERIALS

- White canvas mounted on 32" × 25" stretchers
- Charcoal stick for drawing
- Brushes: flat bristle number 14, round bristle number 8, flat synthetic number 14
- Palette and French-style easel
- Colors: titanium white, medium yellow, ochre, vermilion, alizarin crimson, raw umber, violet, turquoise blue, ultramarine, and emerald green
- Turpentine

1 We begin the composition by looking for the rhythm in the scene created by the various boats. As usual, the preliminary sketch is done with a stick of charcoal. The lines are only approximate at this stage, since our main concern is to adjust the composition to the dimensions of the canvas.

2 The excess charcoal can be removed by simply blowing on the canvas.

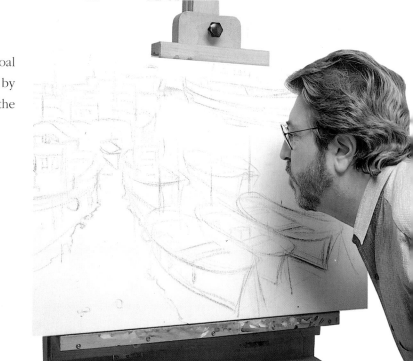

The group of boats on the left create a shadow that has been painted with a dark mixture of emerald green and alizarin crimson.

The color of the large vessel in the background is a mixture of emerald green and white, using different proportions according to the degree of light to be expressed.

The reflections here are extremely diverse. They have been suggested by quick clear strokes of emerald, ochre, and white, toned down with a little raw umber.

The strong light reflected on the boats in the foreground has been suggested with pure white applied with a palette knife.

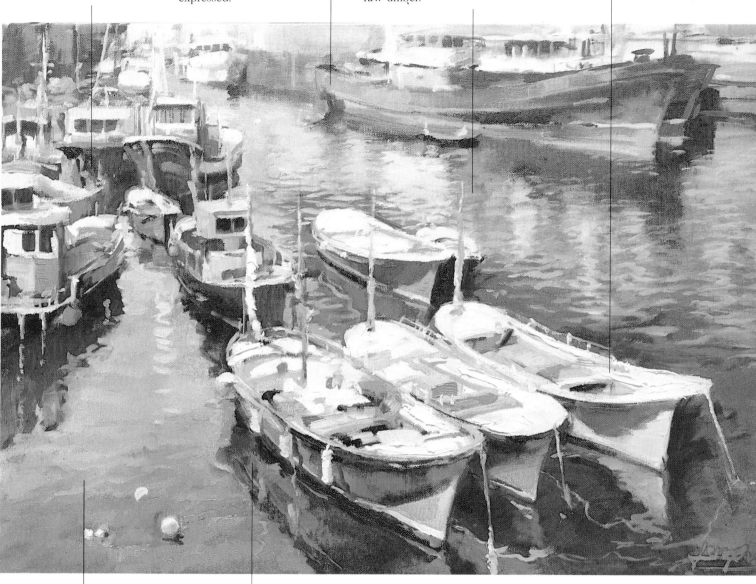

The background color for this part of the water is ultramarine, changing to more turquoise tones in the upper section.

The dark shadows of the boats in the foreground have been painted with pure emerald green with a few light touches of ultramarine.

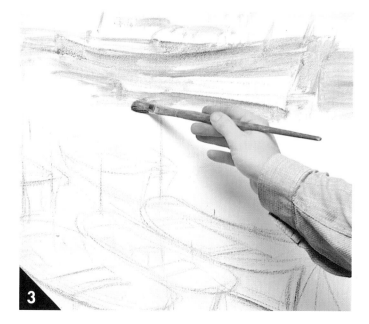

3 We lay down the general underpainting with a highly diluted mixture of ultramarine and emerald green for the background section.

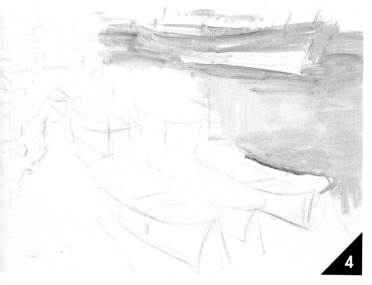

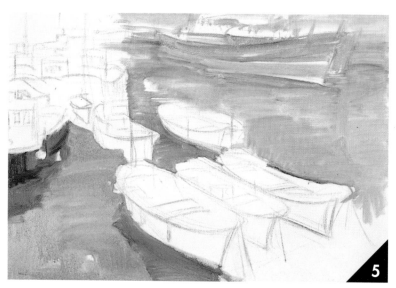

4 A few touches of ochre can be added to the previous mixture. This color is so highly diluted that it looks more like watercolor than oil paint.

5 Working around the shape of the boats, we now add turquoise and ultramarine tones. A strong emerald green then indicates the shadows of the boats.

6 Here we have a first overview of the work. The thin wash covers the area of the water, and work has been begun on the yellow boat at the right.

7 At this stage we move rapidly from one color to another. We now assume that you have enough experience to know how to do this. The darker areas here are painted with a mixture of ultramarine deep and emerald green.

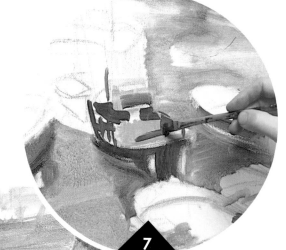

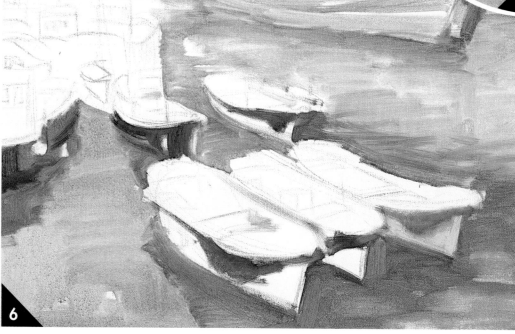

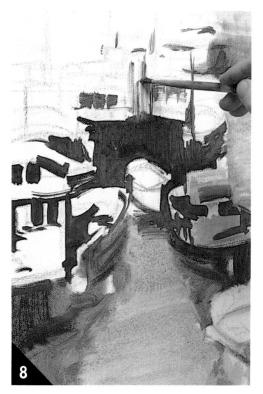

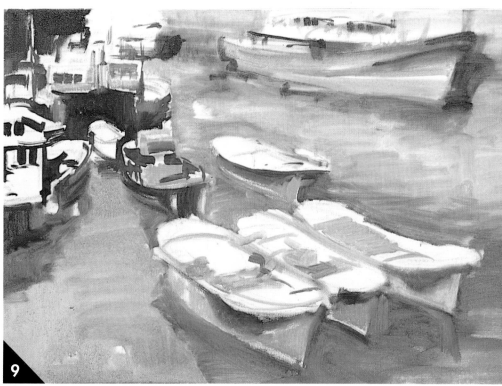

8 We paint the shadows outlining the boats in a strong, dark mixture of ultramarine deep and emerald green. Make sure that each stroke expresses the shape of the boats.

9 Now we see how the painting looks after just half an hour's work. The use of diluted color has enabled us to express the general tones with considerable speed.

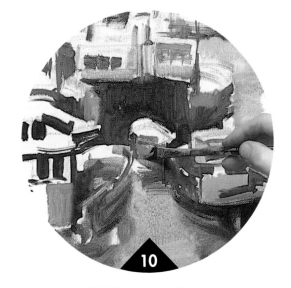

10 Using clear strokes and thick paint, we paint the colors of the various parts. We start this second stage with pure vermilion for one of the smaller boats.

11 We now move quickly to the intermediate tones, adding a series of strokes with a mixture of emerald green, violet, and white. These colors are offset by areas of darker tones.

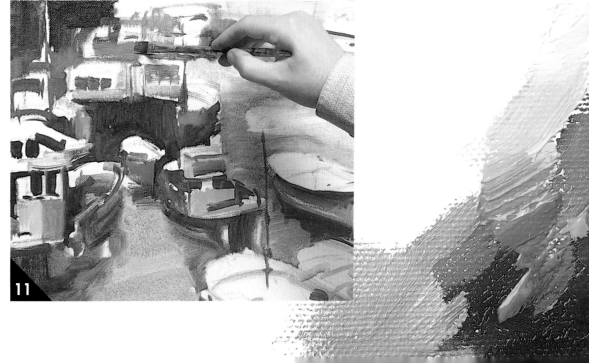

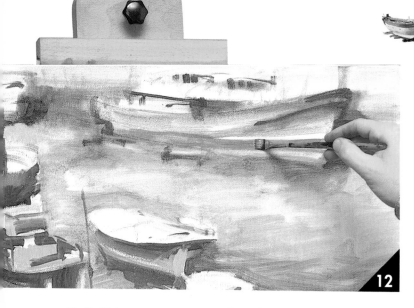

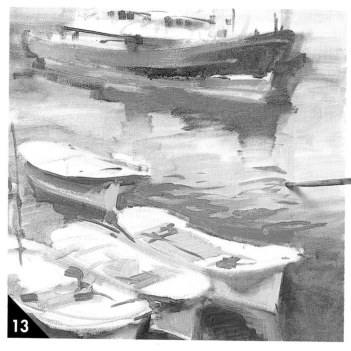

12 Take care not to spend too long on any one section. Here we return to the background to paint in the lower part of the large ship with ochre and a little alizarin crimson.

14 The same mixture of emerald and ochre is used for the ripples made by the ship in the background. These effects should be expressed quite boldly, without getting lost in details. Make sure the work develops as a whole.

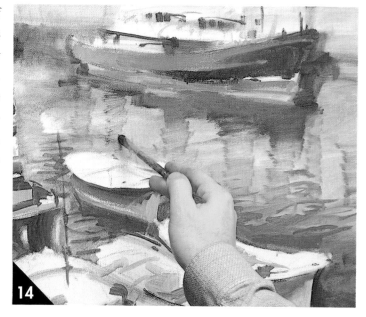

13 Broken horizontal strokes express the texture of the water. The color here is emerald green with a touch of ochre and alizarin crimson, applied with short, horizontal strokes, using the side of the brush.

DEVELOPING THE WORK AS A WHOLE

Whether we're observing the scene or painting it stroke by stroke, our vision must be global, taking in the whole and not only the parts. This means covering the canvas with color as quickly as possible, then constantly moving from one part to another, ensuring that all the parts develop in unison.

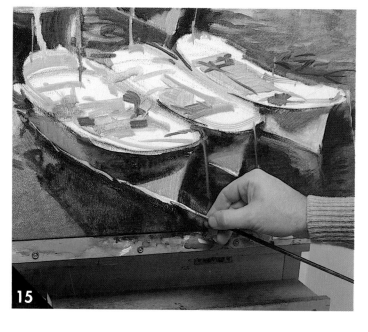

15 Now we gradually start putting in a few details, especially those that help define the structure of the boats. Here a waterline is marked with a fine brush, alternating ochre and white.

16 The same fine brush has been used to color the reflection of the boat with shades of vermilion and a few touches of pure ultramarine in the center. Utramarine has also been used for the reflection just below the waterline. The ochre used to paint this waterline has been toned down with raw umber.

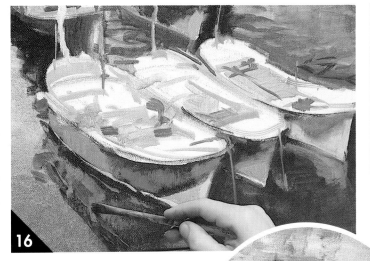

17 Of course, the first strokes of color only give a general tone that now has to be modified and enriched. Now we begin a series of strokes that express the reflections in the water. The color used is turquoise mixed with just a little white to make it more definite.

18 We use the same technique for the areas between the boats, applying the same color mixed with a touch of violet. Notice how the strokes follow the ripples in the shadow of the boat.

19 White slightly toned down with blue now creates a more luminous reflection. The strokes here are quite short and are in a generally vertical direction. They give the effect of a continuous movement.

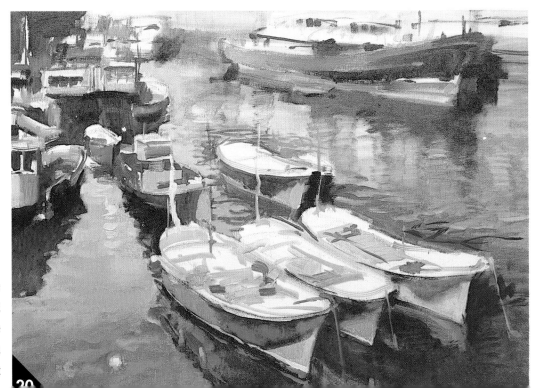

20 Here we have the work in a half-finished state. As you can see, the scene is developing as a whole, with all of its parts at

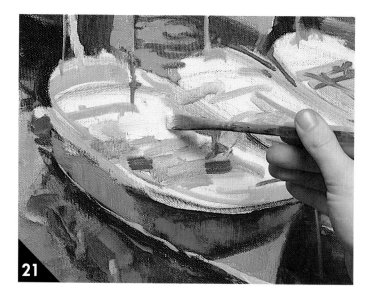

21 All the white areas in the picture so far are unpainted canvas. Now we cover these areas with pure white, working quite freely and making sure each stroke is interesting in and of itself.

22 We start suggesting further details. Here you can see a series of strokes using blues, reds, and raw umber. Each brushstroke is placed so that the total effect gives an impression of considerable detail.

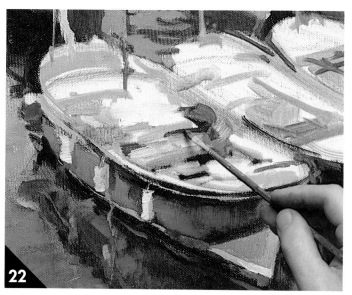

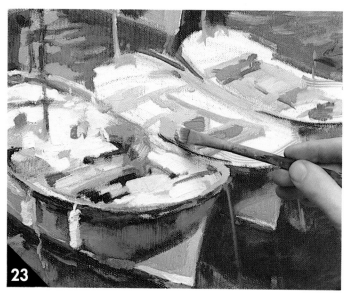

23 The same technique is used to suggest the three-dimensional quality of the boats with various tones of blue, adding light and shade in the right places. The dark areas are based on ultramarine. The lighter colors are a mixture of turquoise and white.

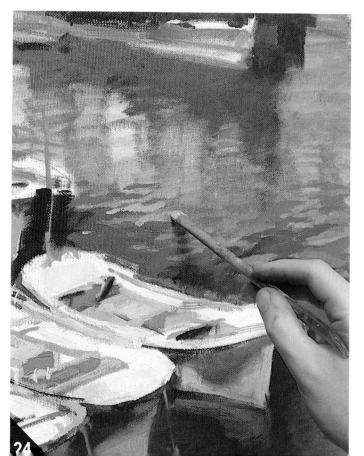

HELP WITH TECHNIQUE

When painting a light color over a dark color that is still wet, make sure your strokes are light and quick enough to avoid any mixing. This means you have to be quite bold. When you first start, the colors will inevitably muddy each other. But with experience you learn how to solve these problems quite easily.

24 Once again we warn you not to spend too long on any one section. Keep moving from one side to the other, keeping control of the work as a whole. Here we add texture to the reflections by using white toned down with a little violet and a touch of raw umber.

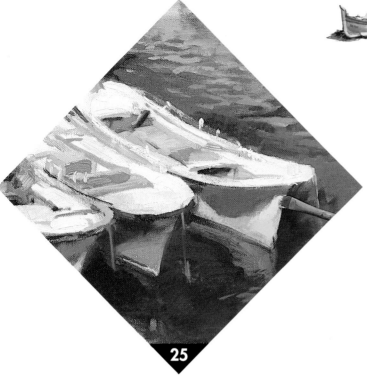

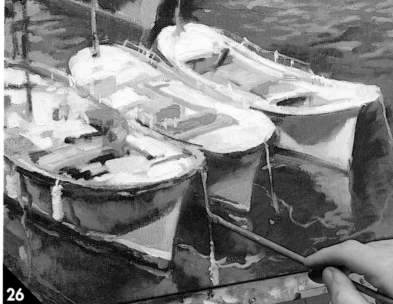

25 We needed a greater contrast of light and shade for the yellow boat. This is achieved with a few clear strokes of pure yellow slightly blended with a little white.

26 Now we go back to our fine brush to put in the mooring lines. These strokes must be applied with great care. Make sure the brush is full of paint. Move from top to bottom without picking up any of the underlying color.

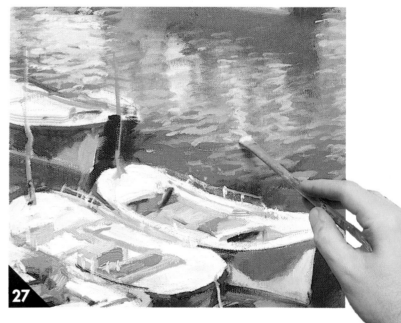

27 The reflections in the middle area of the water are expressed by a series of horizontal strokes in various tones. The colors here are blues, warm grays, and reds that correspond to the colors of the large vessel.

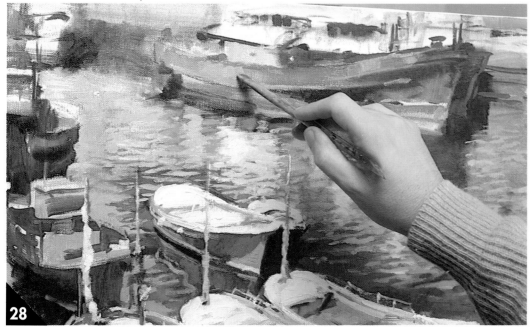

28 The work is now at a very advanced stage. Just a few modifications are required as we go over everything done so far. The photo here shows how we add light to the boat in the background with pure emerald mixed with a touch of white.

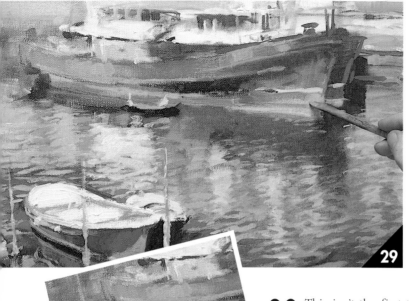

29 Now we modify tones and details, moving from one side of the canvas to the other. Here we have returned to the lower part of the large fishing boat, indicating the waterline with light strokes of ochre and emphasizing the light area on the lower part of the boat. These final strokes should be applied carefully, making sure not to muddy the previous colors.

HOW TO USE A PALETTE KNIFE

When you paint with a palette knife, make sure you start with the exact color you want and that the color is completely mixed on your palette. The layers of paint must be clean and well-shaped, since their function is to give texture and volume. Avoid picking up the surrounding or underlying colors, which would spoil the fresh look that this technique requires.

30 This isn't the first time I've used my fingers. Note, however, that I'm not actually painting with them. The fingers are used here only to smudge and soften the colors in the central area.

31 The section on the left has numerous details in this conglomeration of small boats. These features can be tackled with the same techniques, using a series of bold strokes to give no more than an impression of detail.

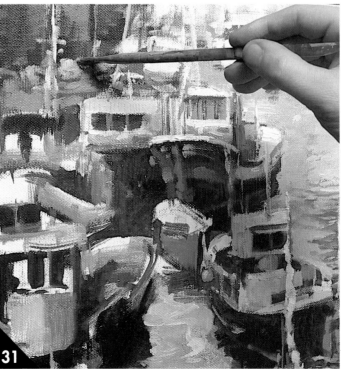

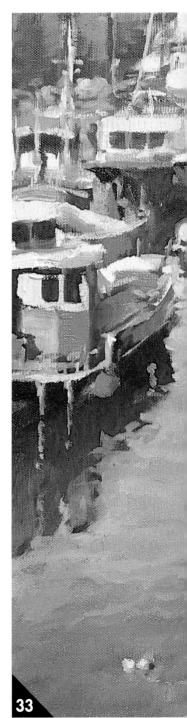

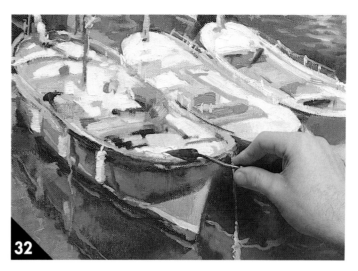

32 We want to make the colors and textures in the foreground even clearer and more vigorous. Here we give them greater volume by applying strong whites with a palette knife.

33 At last, the finished painting. This has been the hardest and most complex of all our exercises, in almost all aspects. If you have followed all the steps and paid attention to the notes, I'm sure you're now very satisfied with the result.

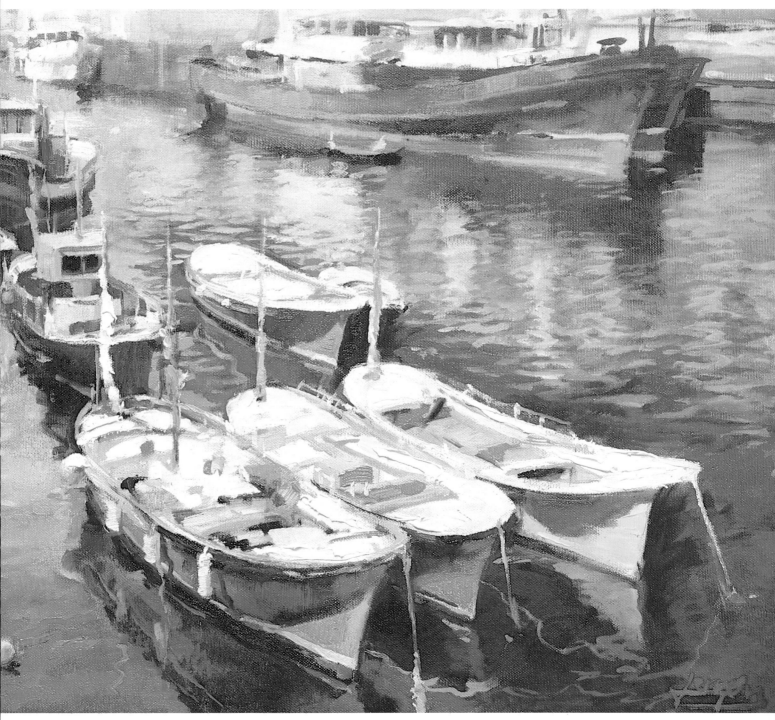

ACKNOWLEDGMENTS

I would like to express my sincere thanks to those who have helped with the preparation and elaboration of this work.

Special gratitude must go to Jordi Vigué, director of publications at Parramón Ediciones in Barcelona, who suggested the idea, approach, and format of this book. I wish to thank him for entrusting me with the responsibility of the illustrations and the accompanying text. He has offered countless suggestions and recommendations for both the preparation and the revision of the volume.

My thanks also to Josep Guasch, who was responsible for the layout and has made the various materials far more attractive than they would otherwise have been.

Jordi Martínez has also contributed with valuable assistance on a thousand points of detail.

I am extremely grateful for the excellent photographic work carried out by the Nos & Soto studio, who showed keen interest throughout the long production process.

Let me not forget all those who have collaborated in the production of this book on both the intellectual and technical sides. And of course, my gratitude to all those readers who have shown interest in my work.

My sincere thanks to everyone.

Miquel Ferrón